UNIVERSAL FLAMENCO

By
Irene Rimer

Flamenco vocabulary contributed by guitarist Tony Arnold

"In the vivid morning
I wanted to be myself.
A heart.

And at the evening's end
I wanted to be my voice.
A nightingale."

Federico Garcia Lorca

Cover Picture: Irene Rimer and Victoria Langdon

Universal Flamenco

CONTENTS

1. History and Philosophy of Music……………..5

2. Flamenco, the Art of the Gypsies…………….20

3. The Meter or Compas……………………………26

4. Basics in Flamenco…………………...………..27

 El Cante, El Baile, El Toque, Las Palmas,

 Other Instruments

5. Mathematics in Flamenco………………………39

6. Flamenco Rhythms or "Palos"………………..42

7. Flamenco Family Tree……………………………45

8. Tablao Flamenco…………………………………46

9. Most popular Flamenco Palos for

dancing in Tablaos………………………….. 49

 Solea, Alegria, Buleria, Siguiriya, Tiento, Tango,

 Fandango, Rumba, and Farruca.

10. Flamenco outside of Spain……………………77

11. Additional Flamenco Vocabulary…………..81

12. About the Author………………………………118

Dedicated to my father,

Dr. Jaime Rimer, a Flamenco aficionado

Universal Flamenco

HISTORY AND PHILOSOPHY OF MUSIC

As mentioned in my first book *Star Logic*, most ancient knowledge has been gained through the study of the scriptures and writings of the Greeks and the Jews that immigrated to ancient Egypt with the purpose of gaining education.

B.C. Egypt was known as the greatest education center of the ancient world; and, it was mentioned by Plato in the *Timaeus* that Greek aspirants to wisdom visited Egypt for initiation, and that the priests of Sais used to refer to them as children in the Mysteries. Mystics have suggested that ancient secret knowledge and its mysteries were learned from survivors of Atlantis living in Egypt after the end of the last age.

The Egyptians considered the archetypal God Hermes, who was attributed with the characteristics of the planet Mercury, to be the founder of art. Hermes, also an Olympian God in Greece, was credited with the development of the lyre. The legend says he created it by stretching strings across the concavity of a turtle shell. He then gave the lyre to the great God Apollo, to the Sun God, as a gift.

Plato declared in his writings that songs and poetry had existed in Egypt for at least ten thousand years, and that the quality was so

great that only God could have created and godlike men composed it.

In the Mysteries of the ancient Egyptian teachings, the lyre was considered the secret symbol of the human constitution. By correspondence, the body of the instrument represents the physical form of man, the strings correspond to the nerves, and the musician is the spirit that plays the instrument. As the spirit of the primal energy that lives in each man seeks expression within the man.

Playing upon the nerves, the spirit creates the harmony required for the normal functioning of the human form. When humans align to the universal order in an upward pursuit for goodness, harmony is exalted as the expression of the will of the eternal good, as man's superior nature is his highest good; or as Marcus Tullius Cicero would say in Latin, his summum bonum, the maximum potential of expressing the highest note that can be channeled through a human embodiment. However, if man defiles his true nature, discord sets which is disharmony, a deformity of harmony which is unnatural.

Even though he was not a musician, the great Pythagoras is attributed with the discovery of the diatonic scale. He was a student of the ancient mysteries who exalted music by demonstrating its truth through mathematics which he considered to be a divine science.

It is said that as Pythagoras meditated on the mysteries of life, he meditated on the harmony of sound and the possible causes of consonance and dissonance. It is said that one day, as he walked the streets of the city, he noticed sounds coming from a brazier's shop where he heard the pounding of a piece of metal upon an anvil. He felt compelled to enter the shop to calculate the variances in pitch between the sounds made by large and small working instruments estimating the harmonies and discords resulting from the combination of the sounds and obtaining the intervals from sound to sound. He proceeded to examine all the tools used and noticed their weight was a factor in the sound. He then went home and created an arm of wood. At regular intervals along this arm he attached four identical cords, of the same composition, size, and weight. To the first of these he attached a twelve-pound weight, to the second a nine-pound weight, to the third an eight-pound weight, and to the fourth a six-pound weight. These combinations were in accord to the sounds of the braziers' hammers he had heard.

Pythagoras noticed the first and fourth strings when sounded together produced the harmonic interval of the octave; and, when doubling the weight, it was noticed that this had the same effect as halving the string. He also discovered that the first and third strings produced the harmony of the diapante, or the interval of the fifth,

and that the first and second strings produced the harmony of the diatessaron, or the interval of the third.

All this research revealed a basic sequence that became the cornerstone of the law of harmonic intervals in the Pythagorean tetractys. The tetractys is a pyramid made of dots using the first four numbers 1, 2, 3 and 4.

```
         •
        • •
       • • •
      • • • •
```

As far as the music tones are concerned, it is said Pythagoras worked his theory of harmony from the monochord consisting of a single string stretched between two pegs and supplied with movable frets.

Pythagoras applied his law of harmonic intervals to everything in Nature and developed what is known as the sidereal harmonics. In his concept of the music of the spheres, the interval that is between the earth and the sphere of the fixed stars was considered the entire range of an instrument, a diapason.

Universal Flamenco

Pythagoras and his followers demonstrated the relationship of intervals of the planets and assigned to each a tone, a harmonic interval, a number, a name, a color, and a form. They thought of the universe as an immense monochord, with its single string connected at its upper end to the spiritual realm and at its lower end to the world of matter, a cord stretched between heaven and earth. These connections revealed a synthesis by correspondence of everything in nature in relationship to the basic numbers, represented by the tetractys, and by Kabbalah's tree of life. Color frequencies, vibrations of tone, the human body, all things in nature are ruled by the divine numbers, and follow a universal law of correspondence.

Pythagoras divided the universe into parts, some studies say nine parts, other studies say it was twelve parts. Starting with the spiritual division at the top, he listed the planets in the following order per division: Saturn, Jupiter, Mars, the sun, Venus, Mercury, and the moon (the sun and moon being regarded as planets in old astronomy.) This order coincides with the candles order in the Jewish Menorah, with the sun in the center as the main stem and three planets on either side of it, the last division (or four if considering twelve divisions instead of nine) were the earth's elements of fire, air, water and earth.

Pythagorean's division of the Universe.

The Sun, represented by the middle lamp in the menorah, at the center of the planetary energies is corresponds to the ego of man as in projective geometry, where the center of projective space is at the center of every being. As in the nucleus of the atom, the center of the universe is in the center or heart of every being, the microcosm.

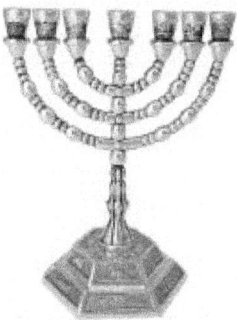

The menorah

In paragraph 7 of chapter 6 of the book *Antiquities*, the Jewish historian Josephus wrote that the seven lamps of the golden menorah that lit up the Temple of the Most High God in the tabernacle represent the seven classical planets in the same order listed by Pythagoras; the Moon, Mercury, Venus, the Sun, Mars, Jupiter, and Saturn. Notice that the ancient Scriptures mention that God resided within the tabernacle in the dessert; as a drop of the primal energy, God, is within the physical embodiment of man while he is on earth.

According to the Roman writer Macrobius, the names given to the various notes of the Pythagorean diatonic scale were derived from an estimation of the velocity and magnitude of the planetary bodies. The idea is that as the planets move through space they make a tone caused by their continuous displacement of the ether; therefore, the tone of sound of the planets is a manifestation of divine order and motion that influence all in the universe, individually and collectively. This concept was common in ancient

Greek writings. Saturn, the farthest planet, was said to cause the gravest note, while the Moon, which is the nearest, made the sharpest sound.

"There is geometry in the humming of the strings... there is music in the spacing of the spheres...everything is created out of whole numbers. From their ratios, differences and sums everything is made. The spheres are arranged by their immutable laws, rotating in eternal harmony. In the same way we can attain perfect harmony with the cosmos by opening our minds to the truth of numbers." *Pythagoras (6th Century B.C.E.)*

Realizing that all is one, that all comes from one and goes back to one, the ancient Greeks also recognized a correspondence between the divisions of heaven and the seven planets, with the seven vowels. The first heaven corresponds to the sound of the vowel A (Alpha); the second heaven to the vowel E (Epsilon); the third, H (Eta); the fourth, I (Iota); the fifth, O (Omicron); the sixth, Y (Upsilon); and the seventh heaven to the vowel Ω (Omega). Let us remember who said, "I am the Alpha and the Omega," says the Lord God, "who is, and who was, and who is to come, the Almighty" (Rev. 1:8). The correspondence is in all.

It was said that when these seven heavens that correspond to the planets and the vowels sing together, they produce a perfect harmony which ascends as an everlasting praise to the throne of

the Creator. Although not specified in writing, it is probable that the planetary heavens were considered to be in ascending order beginning with the division of the moon, which would be the first heaven or sphere.

In correspondence with the above, many early instruments also had seven strings representing the seven planets. The seven planets and the seven strings in instruments were also in correspondence with the human body and its seven energy centers, the seven endocrine glands or chakras in Hindu metaphysics.

The ancient seers, the Pythagoreans, believed that everything that existed in the universe had a voice and that all creatures were eternally singing the praise of the Creator; that sensual men fail to hear these divine melodies because their soul is enmeshed in the illusion of material existence. When man liberates himself from the bondage of the lower world with its sense conceptions which are a limitation, the music of the spheres will again be audible to him as it was to the men called seers during the Golden Age.

As mentioned in my first book, *Star Logic,* the men of the Golden age were called seers because they possessed internal sight as well as internal hearing. As the axiom "like attracts like," harmony recognizes harmony, and when the human soul regains its true estate it will not only hear the celestial choir but also join with

it in an everlasting anthem of praise to the eternal Goodness of the creator; this will all be in harmony.

The Greek Mysteries also included in their doctrines an excellent concept of the relationship between music and form. For example, the elements of architecture were considered as comparable to musical modes and notes, or as having a musical counterpart. Therefore, when a building was erected in which a number of these elements were combined, the structure was then likened to a musical chord, which was harmonic only when it fully satisfied the mathematical requirements of harmonic intervals. Knowing this, we can understand Goethe when he stated that *"Architecture is crystallized music."*

In constructing their temples of initiation, the ancient priests frequently demonstrated their superior knowledge of the law of vibration. A considerable part of the Mystery rituals in which they engaged consisted of invocations and intonements, for which purpose special sound chambers were constructed. A word whispered in one of these constructions was intensified so that the vibrations would make the building sway and be filled with a very loud roar. The wood, the stone, and all other materials used in the erection of these sacred buildings became so thoroughly permeated with the sound vibrations of the religious ceremonies through the years, that when struck again, the same tones would be reproduced

without much effort repeatedly as if these were impressed into the structure's substances by the rituals.

Every element in Nature has its unique keynote. If these elements are combined in a composite structure, the result is a chord that if sounded would disintegrate the compound into its integral parts. Each person, composed of minerals, also has an individual keynote. The story of the falling off the walls of Jericho at the sound of the trumpets of Israel shows the power of tone and the significance of keynotes, or vibrating power. The story tells us that,

"Now Jericho was shut up inside and outside because of the people of Israel. None went out, and none came in. And the Lord said to Joshua: See, I have given Jericho into your hand, with its king and mighty men of valor. You shall march around the city, all the men of war going around the city once... Seven priests shall bear seven trumpets of rams' horns before the ark. On the seventh day you shall march around the city seven times, and the priests shall blow the trumpets. And when they make a long blast with the ram's horn, when you hear the sound of the trumpet, then all the people shall shout with a great shout, and the wall of the city will fall down flat" (Joshua 6, 1-7).

The Ancient Greek modes

The ancient Greek modes are a series of different seven-note diatonic scales containing five whole tones and two semitones of which nucleus was the tetrachord—a group of four consecutive notes, as from C to F on the piano, comprising the interval of a fourth. The basic tetrachord consisted of two whole tones and one semitone, E–D–C–B. Two of these tetrachords separated from one another by a whole tone, formed what is known as the Greek Dorian mode or basic church mode:

E–D–C–B A–G–F–E.

It is worth here to remind to the reader that the notes in the Pythagorean scale were arranged in a descending order not by chance. There was a reason, and it had to do with involving and evolving, ascending and descending, waves of sound.

The Dorian mode served as a basis for other systems. Its single-octave range was extended by the addition of a third tetrachord, A–G–F–E, on top and of a fourth tetrachord, E–D–C–B, at the bottom. In contrast to the two inner tetrachords, which were separated by a whole tone, each outer tetrachord was linked with the neighboring inner one by a shared note, the octave, which was the beginning of a new sequence.

A G F E D C B A G F E D C B.

Universal Flamenco

Because the combination of the four tetrachords yielded a range of two octaves minus one whole tone, a low A was added by theorists to achieve the following diatonic two-octave system:

A G F E D C B A G F E D C B A. This two-octave row, or diapason, was called the Greater Perfect System.

It was analyzed as consisting of seven overlapping scales, or octave species, called harmoniai, characterized by the different positions of their semitones.

AGFEDCB**A** - Hypodorian

GFEDCBA**G** – Hypophrygian

FEDCBAG**F** – Hypolydian

EDCBAGF**E** – Dorian

DCBAGFE**D** – Phrygian

CBAGFED**C** – Lydian

BAGFEDC**B** - Mixolydian

According to the Greek Doctrine of Ethos, each Greek music mode gave a different music ability of influencing human actions in a certain way. For example, the Dorian mode produced forceful and rigid feelings while the Phryan mode expressed passionate and intimate emotions. According to legend, the Phryan mode was once

thought to possess the power to intoxicate those who heard it and therefore was made illegal at a time; interesting and pertaining to this book is that this is the fundamental tonality of most flamenco music. The Lydian mode was also considered "dangerous" because it was believed to entice intimate and lascivious behavior. In the *Republic* Plato stressed the educational values of the Dorian mode and warned against the weakening influence of the Lydian mode.

Ancient Hebrew music followed the well-established modal patterns of the Greeks. This was confirmed by Abraham Zevi Idelsohn, a prominent ethnologist, composer, and musicologist, whose comparative research in the 20^{th} century helped in the understanding of the Hebrew modes which influenced the early Christian chanting done at the churches. Correlations can be seen in the comparison of a plainchant Kyrie, in the third mode, with a Babylonian Jewish melody for a phrase from Exodus.

Also, influenced by the ancient Greek models was the Byzantine music which in turn greatly influenced the music styles of the European countries. The tradition of eastern liturgical chant, encompassing the Greek language, developed in the Byzantine Empire from the time of the establishment of its capital, Constantinople, in 330 until its fall in 1453. Chants were composed to Greek texts as ceremonial, festival or church music, greatly

influencing the artistic and technical productions of the classical Greek age.

The Byzantine Empire was the predominantly Greek-speaking continuation of the Roman Empire. This is the reason it was also known as the Romania, and the "Empire of the Romans;" the Romans being its inhabitants. Romania's capital, Constantinople, was originally known as Byzantium. In 380, Constantinople, the city of Constantine, and all the Byzantine territory, adopted Orthodox Christianity as its official religion.

The Gregorian chant which developed within the Byzantine music had a great influence in the birth of Flamenco in Spain since church music is at the heart of the Flamenco soul. This can easily be sensed in the cante jondo repertoire, especially in the Tona Liturgica, Tona Grande and certain Saetas and Seguiriyas.

The Gregorian chant was the outcome of several oral traditions following those that existed in Jerusalem and Byzantium before and during the Catholic Monarchs re-conquest of the South of Spain from the Muslims in 1492. These oral traditions were generally improvisational within a set structure, a form. Common known wording as cadence and typical measurement formulas such as scales and the meter for rhythm were used.

Composer Manuel de Falla wrote that the Spanish Church's adoption of liturgical chant, the Muslim invasion, and the arrival in Spain of numerous bands of Gypsies gave the Flamenco cante jondo its definitive form.

FLAMENCO, THE ART OF THE GYPSIES

On Nov. 16th, 2010, UNESCO declared Flamenco one of the Masterpieces of the Oral and Intangible Heritage of Humanity.

Flamenco is an art-form of song, dance, and instrumental music, mostly associated with the Romani people of Spain called gypsies (gitanos.) This art-form is a soulful way of expression that seems to have emerged out of the suffering and pain endured by the Moors, Jews, and Gypsies during the persecution of the 15th century under the rule of the Catholic king and queen, Ferdinand of Aragon and Isabella of Castile.

Flamenco emerged in Southern Spain, Andalusia, of a mixture of Romani, local Andalusia music, and dance styles of rooted Jewish, Arabic, Indian, and Byzantine influences that can also be traced to the ancient Greeks and before that, the Egyptians. Around 1,000 A.D., large groups of nomad Romani people immigrated to Spain from Northern India. As they travelled, they camped and stayed at different places for long periods of time and so their culture and music influenced all other groups in their way to Andalusia through

Universal Flamenco

North Africa. It was because they reached Andalusia through North Africa that the Romani were called gypsies. The word Gitano is from "Egipciano" in Spanish meaning "Egyptian," as the word "Gypsy" in English which is derived from "Egyptian." However, it's not easy to pin point exactly when Flamenco originated as even the precedence of the word Flamenco itself is not known to this day.

Before the invasion of the Moors in the seventh century, Spain had its own liturgical music forms that proceeded from the Visigothic or Mozarabic rite, a form of Catholic worship within the Latin Church of the Catholic Church and in the Spanish Reformed Episcopal Church, with Byzantine influence. These local music forms and the culture of all newcomers to the area blended. The emergence of a strong cultural mix in music became more noticeable after the invasion of the Moors of the Iberia peninsula which was named Al-Andalus from which the name Andalusia derives. Upon their conquest, the Muslims established their Caliphate in the city of Cordoba which became a cultural center in both the Muslim and Christian worlds.

During the existence of the Caliphate, the economy grew very strong, successful, and diverse. It consisting primarily of trade which attracted musicians from all Islamic countries including Zyriab, who imported forms of Persian music and revolutionized the shape and

playing techniques of the Lute, instrument from which the guitar evolved.

The Moors occupied Spain for seven centuries, from 711 to 1492 A.C, and became a strong influence that definitely molded the cultural diversity of the country. There was also a large population of Jews in Spain because they enjoyed certain ethnic and religious tolerance there that they didn't enjoy in any other of the surrounding "Christian" countries; therefore, their culture also blended with the locals until they were expelled at the end of the re-conquest by the Catholic Monarchs.

Before and during the time of the discovery of America in 1492, there were large groups of nomad Gypsies arriving to the area. This was a very busy time in history. It was on this same year that the Catholics completed their re-conquest of Spain with the invasion of the last Muslim stronghold in Andalusia, in the city of Granada.

Initially at that time, the royals had agreed to a treaty where religion tolerance was guaranteed to the people; however, they later retracted due to their political ties to the Church of Rome, and increasing pressure from the Spanish inquisition. In the Alhambra decree the Catholic monarchs ordered all people to convert to Christianity; they also ordered the expulsion of all non-converted Jews from Spain. Some chose to convert instead of leaving; but, they kept their customs and beliefs in secret facing persecution,

torture and even death if they were discovered to continue their religious practices.

These decrees caused large groups of Muslims, Jews, and Gypsies to move into the surrounding mountains and the rural areas of the country to hide and blend with the Christians. Groups of Muslims that converted to Christianity but also kept their customs were known as Moriscos. They were also later expelled from Spain, even though they were in their own country of origin. According to some historians on the subject, the Moriscos joined the incoming Gypsy tribes and mixed with them. To prove this, they point to the fact that the Zambra of the gypsies of Granada is originated from the Moorish Zambra. There are many other resemblances in the art culture that indicate the mix was likely to have taken place.

During the following century, large groups of Romani tribes, the gypsies, continued to arrive into the area. The Spanish nobles tolerated the Gypsies at first. It was customary of the time to employ them to entertain at social gatherings, as portrayed in Verdi's Opera "La traviata," in which gypsies were hired to dance and sing at a party. The gypsy art-form was well liked, animated, and happy although the gypsies themselves were discriminated.

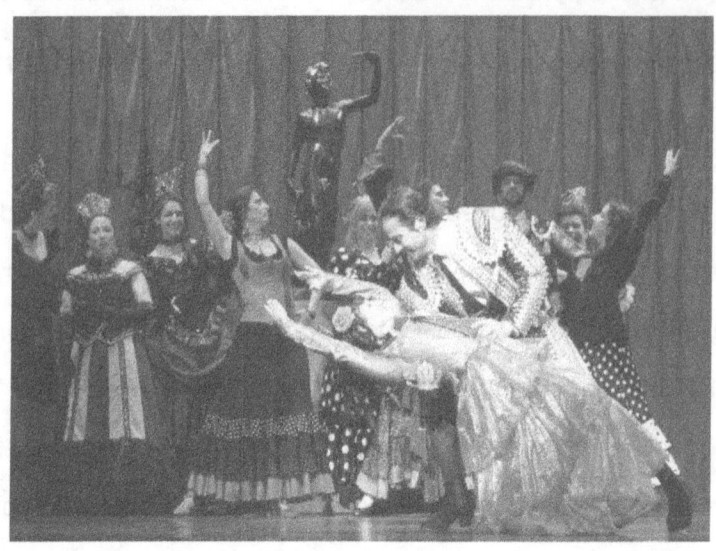

Irene Rimer & Corazon Flamenco in the gypsy scene from Verdi's la traviata at the Alabama Theatre in Birmingham, Alabama.

There was continued animosity between the Spaniards and the gypsies as the later group attempted to force the gypsies to abandon their customs, language, and music, as it had been done to the Jews. Gypsies that were not able to be assimilated into the general Christian culture in Spain were forced to live in ghettos. However, situations seen as "bad" at first may not be bad at all. This isolation served to keep Flamenco music and dance pure from outside influences. Nomadic Gypsies were treated as social outcasts and were also persecuted. The hardship endured by the Gypsies was reflected in a lot of the lyrics in their songs which themes are mostly related to hard labor, discrimination, hunger, prison, injustice, and unequal or prohibited love. The album *Persecusion* by

Universal Flamenco

Juan El Legrijano is a compilation of songs that tells the story in Flamenco song of the burdens of the persecution during the 15th century in Spain.

It was not until in 1782 that the gypsies were reintroduced to the general population due to King Charles III finally granting them freedoms. This time marked a period of expansion and development of Flamenco as the gypsies started to emerge from the ghettos and to share their art, although they also assimilated new influences.

During the 18th century Flamenco's popularity grew as the 6-string guitar became the instrument of choice in Flamenco performances and juergas (gypsy parties.) These Flamenco fiestas became customary of weddings and birthday celebrations that sometimes lasted for days. As flamenco evolved by the following century, it gained popularity outside of Andalusia. The art-form became more demanding of the skills performers developed as dancers, musicians, and singers gained reputation and even competed among themselves to advance their skills and to be recognized.

THE METER OR COMPAS

Flamenco rhythm, known in Flamenco as compas, is a basic unit, a structure, or frame of 12 beat-counts. Phrases or melodies of music, song, and dance flow in order within this frame.

This basic rhythm of Flamenco framed in 12 numbers is separated by perfect intervals where five points are emphasized; the recurring pattern of accented beats is analogous to a measure of music, but usually more extended. This frame dictates the rhythmic structure of any given song or dance form. Due to the belief that some groups of the gypsies migrated from North India during the 7th century, it is worth noting that the concept of compás is quite similar to the "taal" rhythmic form of Indian classical music as well.

The maintenance of a steady and reliable compás is essential to all flamenco cante and dance. To this end, many beginners count the compás out loud or in their heads, while recognizing that the ultimate goal is performance based on an instinctive feel rather than the rational understanding of the compás. This is the reason

that the 12-count rhythms deserve to be explained further as there are several alternatives for counting. That is, that the 12-count rhythms can be counted in more than one way, all of which are valid for learning as far as they make up 12.

One method is to count all rhythms with cardinal emphasis on beats 3, 6, 8, 10, and 12, as illustrated above on the basic compas. Another is to treat the melody as always beginning on the first beat, and then emphasize the beats appropriate to the particular melodic rhythm, or what is known as palo, being performed. For example, in the siguiriyas' rhythm cardinal beats fall on 1, 3, 5, 8, and 11. This is further explained later in the book. The compás sounds the same regardless of which counting method is used, but fluctuating methods invariably lead to confusion for the beginner student.

THE BASIC FACTORS IN FLAMENCO

El Cante, the song

El Cante, or song, is the essence of Flamenco, its spirit and soul. It falls into three categories: Cante jondo, Cante chico, and Cante intermedio.

Cante jondo or "deep song" is believed to be the oldest form of Flamenco based on the basic 12-beat Compas. It is soulful in that it is characterized by deep emotions dealing with tragic themes such

as death, anguish, and despair; it is no doubt this cante sprang from the suffering and pain of the persecuted people of the time as a way of releasing the feelings of frustration and pain. The strong Byzantine influence is mostly sensed in in this type of cante, the Cante Jondo.

Cante chico or "light song" is generally simpler in rhythm than other forms, sometimes counted as a fraction of the 12-beat basic rhythm. This type of cante is considered lighter because it doesn't involve the pain themes associated with the cante jondo; it, nevertheless, also requires technical skills. The themes involved with this type of song are usually concerning everyday life subjects of love, happiness, friendship, nature, and good humor.

Cante intermedio or "intermediate song" sometimes also known as Cante flamenco is whatever Andalusian song not categorized as Cante jondo or Cante chico; it falls in between these two other categories.

Even though the several types of Cante may share the same rhythmic beat count, each song style is recognized by a characteristic rhythm frequency, chord structure, individualized melody, different accentuation, and in some cases a different emotional content which makes it unique and distinguishable.

Universal Flamenco

The origin of many Flamenco song styles can be traceable. For example, the soulful, sad and serious Solea is said to come from the Cañas and the Polos that in turn emerged from the Tonas. Although some flamencologists suggest that the Solea came first after the Tonas. If you listen to these songs you will notice they are similar, and obviously closely related.

The Alegrias was inspired from the Solea as it shares many of its elements. The Alegrias originated in Cadiz; out of it many other light-song types were developed, such as the Bulería which is one of the most popular styles.

The Alboreás is traditionally sung only at weddings and is considered "unlucky" if sang during other occasions; as the Peteneras that sprang out of the Sephardic Jews blues. To this day, the Peteneras is considered an unlucky song to be played, sang, or danced. Other forms, such as the Fandangos grandes, were adopted from Spanish folk song and dance; the Fandangos becoming more serious in character than the original and begetting a series of descendants that includes the Malagueñas and the Cartageneras.

Some songs have Latin American influence such as the gypsy Rumbas, the Guajiras, and the Colombianas which most certainly originated after the discovery of America due to imprisoned gypsies being sent as slaves to do force labor to the new discovered

continent. In the new world, they experienced new sounds that inspired them to create new melodies and styles which were taken back to Spain to be included and blended with Flamenco.

There are also songs with deep Gitano flamenco tradition such as the Siguiriyas and the Saetas which, as previously mentioned, were adopted from the Spanish religious processions; also the Martinetes, an early song type inspired by the sound of the beating hammer against an anvil. This sound creates an atmosphere reminiscent of the chains on the prisoners of injustice and reflects the pain and sense of persecution felt by generations of discriminated gypsies.

There is no complete Flamenco without the cante which tells the story, the circumstance. This is the reason the song or human voice is considered the spirit and soul, the life, as it is essential within this art-form.

El Baile, or dance

Flamenco dancer Estrella Morena from Madrid. Estrella and her husband, Pepe de Malaga, perform and teach in Miami, Florida.

The Flamenco baile (dance) is the form. The spirit and life expressing itself through the body in motion. Flamenco differs from many other dance forms in that it is very personal and emphasizes in uniqueness and originality. Even when several dancers perform a choreographed set of steps, they are never "copy cats," but originals. They don't follow anyone but keep their individualized personalities even when doing the same steps.

Flamenco improvisation of the form is encouraged when the performer masters the rhythm. In gypsy homes, Flamenco is infused to the person from the beginning of life; therefore, it is common to

see the gypsy women singing and dancing even when doing house chores and cooking. Family reunions in Flamenco homes orbit around the singing, the percussion, and the dancing when all get together during celebrations. There is no age requirement to enjoy this art of precision, and strength.

In the baile, the movements are sensuous and stylized. They involve arm movements (known as braceo) and upper torso postures; the hand and finger movements (known as florea) which resemble those done in classical Hindu dance and other oriental styles that must have been inspired from the opening and reaching upwards of the flowers of nature; and, the footwork (known as zapateado or escobilla), with intrinsic heelwork (taconeo.) Footwork is often emphasized in long solo dances, and requires physical strength, and great precision.

Traditionally, male dancers emphasized and performed more of the complicated athletic footwork while female dancers focused on the hands and upper torso movements while wearing elaborately ruffled dresses, and many other accessories to adorn themselves. This tradition was transcended by many women who made great efforts in developing their footwork technique such as the late famous Flamenco bailaora (dancer) Carmen Amaya.

It is said that during a deep-felt Flamenco dance such as a Solea or Siguiriya the dancer falls into an emotional trance called

Universal Flamenco

"duende." This is a moment of intense focus and connection to the spiritual world, when the dancer's souls find the deepest outward expression. The Spanish poet Federico García Lorca described these moments of profound emotional depth and sound as "los sonidos negros" (the dark sounds,) which are said to invade the performer's body and reveal the soul of the person through art.

Among the many great Flamenco dance performers are bailaora Carmen Amaya, La Argentina (Antonia Mercé), Vicente Escudero, Encarnación López, José Greco, and Pilar López. Great and famous also were the troupes of Antonio and Rosario (Antonio Ruiz Soler and Rosario Florencia Pérez Podilla) and Ximénez-Vargas (Roberto Ximénez and Manolo Vargas); also flamenco dancers Antonio Gades, Christina Hoyos, El Guito and José Greco II who internationalized Flamenco by performing in movies.

El Toque, the Flamenco guitar

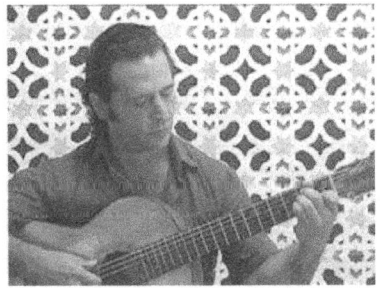

Guitarist Manolo Vargas from Seville often performs with Corazon Flamenco and teaches guitar in the San Francisco area.

The Flamenco guitar became inseparable with the art-form and it is the instrument of choice of Flamencos. The guitarist, as well as the palmeros (hand-clappers), follows and keeps the compás (rhythm) established by the dancer who leads the performance. The skill to maintain the compass is necessary of all performing so that there is harmony within the law or frame of the palo (rhythm) being performed. The guitarist adds melody and keeps the tone of the song.

As mentioned earlier, the first guitars originated in Spain during the 15th century at the time the different culture influences blended and developed with open trade stimulated by the late Caliphate of Cordoba. With the increase of trade, a lot of musicians migrated to the area at that time including the Iraki teacher Zyriab who contributed to the development of the classical guitar as well as the Flamenco guitar.

The traditional flamenco guitar is made of Spanish cypress and spruce, and is lighter in weight and somewhat smaller than a classical guitar, to give the output a 'sharper' sound. Unlike the Classical guitar, the flamenco guitar has a tap-plate known as a golpeador to protect the wood of the guitar from the rhythmic taps, called golpes that are used in the art-form; guitarists also use a cejilla (or capo) to makes changes to the tones of music to accompany the singers.

Universal Flamenco

Some of the greatest guitarists of all times are Paco de Lucia, Nino Ricardo, Sabicas, Ramon Montoya, Manolo Sanlucar, Tomatito, Vicente Amigo, Paco Fernandez, Jeronimo Maya, Rafael Cortez, Canizares, and Nino Miguel.

The truly great flamenco guitar makers are recognized worldwide for their skills, experience, and art in the construction of the Flamenco guitar. Sometimes they are families working is small workshops and making only up to 20 guitars a year with a long list of consumers waiting. These makers only make originals sometimes taking about 300 hours of manual labor per guitar and using very old aged premium grade of solid woods. They have the ability to adjust top, back and sides or braces in relation to the specific sound characteristics of each single piece of wood, thus controlling the quality and sound during the construction phase. Some of these famous guitar makers are: Jeronimo Maya Guitars, Santos Hernandez, Conde hermanos, Gerundino Fernandez, Manuel Reyes, Domingo Esteso, Francisco Barba, Pedro de Miguel, Vicente Carrillo, Salvador Castillo and Aaron Garcia.

OTHER FLAMENCO INSTRUMENTS

Palmas (hand clapping)

Ilene Brill, bailaora, of Corazon Flamenco

There are also those that clap (called palmeros) to the beat in order to emphasize the accents in the rhythm and aid the other performers keep rhythm within the established frame of time as drummers do in modern popular music.

In Spanish, palmas in Flamenco music refer to hand clapping, which is an essential rhythmic element to the genre for musicians as well as dancers. The claps accentuate the more important beats of the song and provide a solid sound of frames in which contra tiempos (contra beats) can be added. Contra tiempo is syncopated rhythm; counter rhythms of beats other than the main beats of the compas.

Palmas Fuertes (hard) and palmas sordas (soft) are used to denote any of the nuances among the forms. Softer claps are

Universal Flamenco

usually used during guitar or vocal solos, and harder claps are used during the more intense parts of the songs, such as when dancers are stomping their feet during a zapateado (footwork) or when the music gets particularly loud and fast usually right before a break, or before the end of the dance at the 10th beat-count.

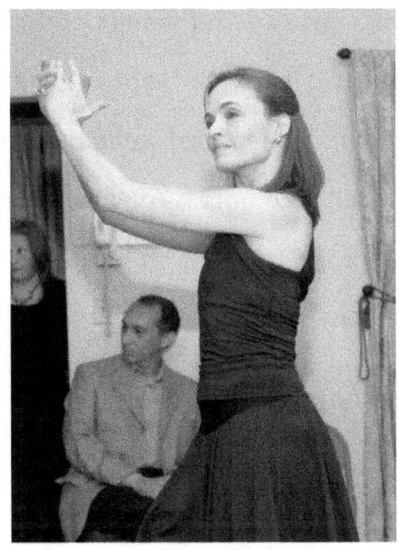

Mary Jo Crews, bailaora, of Corazon Flamenco

El Cajon

The cajon was recently introduced into Flamenco music in the 1970s. Literally meaning crate or drawer in

Spanish, the cajon is a specially designed box on which the player sits while slapping the front and top edge to produce percussion sounds. On the back side of the cajon there is a hole cut in order to release lower notes, which are played either with the side of the fist or the heel of the palm. The top inside of the cajon is lined with snares, much like a snare drum, which produces a sharp sound when the top is hit, usually with the heel of the palm or the fingers. Many cajon players also use their feet to tune the cajon (when the instrument has this tuning feature) while playing in order to produce differently pitched notes. The cajon is made from thick wood on all sides but the front which is made from plywood in order to allow for more resonant strikes.

Los Palillos (Castanets)

Palillos, or castanets as they are more commonly known, are a hand percussion instrument made from two concave shells that are attached by a string. The shells are made of stone, wood, or more commonly, fiberglass. Much like with claves of other Spanish or Latin music, the player strikes the two shells of the palillos together, often in a repetitive pattern, to create a high pitched and sharply contrasting clicking sound. A set of

palillos are used at the same time on both hands; they are hand sized and pitched differently.

The right hand plays the palillos with all the fingers except for the thumb where the string hangs from. The left hand serves as a bass to the sound using only the middle two fingers at the same time.

MATHEMATICS IN FLAMENCO

With its ancient Egyptian mathematical influence, Flamenco music exists within numerical frames. It combines the emotions with form, where counting is not required when the space order is mastered by intuition as this art-form is usually learned by "feeling" it.

Students of Flamenco sometimes encounter a lot of difficulty when trying to rationalize these feelings into the rhythmic patterns they are confined to. If they do not understand the patterns, they are not able to perceive how precision is required in the dance. A dancer that "feels" will usually get precision faster than the one that is analyzing without feeling. A person that overanalyzes will get stuck. It's easier to understand the rational aspects once the feeling is there.

When learning the spacing between the beats, in the clapping of two half beats in the place of one whole beat, one will eventually understand the spacing of the fractions in between beats, or the full cycle of 12-beats. Learning to beat a half time, a quarter time, or an eighth time will enable a Flamenco student to feel the fractions in their own blood as they also begin to work with the larger mathematical themes within the Flamenco rhythm which are the patterns, of active and passive sequences, their connections and changes.

The idea of the different patterns emerges as the Flamenco students put together steps, sounds, and movements to create their performances. Mathematics can be "seen" as the dance students consider the shapes they make with their rhythmic accents during the cycles, similar to geometric figures as they are incorporating movement with their bodies.

As mentioned already, the word Compás is the Spanish word for rhythm or time. It is the frame of a rhythmic cycle of flamenco style. Again, it is important when performing flamenco to feel the compás, and enjoy the dancing, rather than rationalize and mechanically count the beats; although it is by counting that many learn it initially.

Flamenco uses three basic counts or measures: binary, ternary and the basic twelve-beat cycle which is said to be unique to

Universal Flamenco

Flamenco and can be traced to Pythagorean math and the truth in the complex of twelve parts, the circle of 360 degrees, and the clock. There are also free-form styles, not subject to rhythm. These are usually very spiritual and include the Saetas, Tarantas, and some Fandangos among others.

In Flamenco dance, there must be perfect harmony, and although there is a law which forms a frame for the dance, there is freedom for each of the performers to improvise according to a "felt" tradition or ethical pattern. Between parts of the cante called letras, or coplas, and the steps of the dancer, the guitarist can play any number of falsetas (melodies) or guitar solos accompanied by the marking of the compas by hand clapping. During the cante, the singer takes center stage and the time allotted for his narrative of the story of the song is given before the dancer claims the stage to improvise as well. When the guitar player is playing his solo, the singer waits, while the singer tells the story, the dancer waits, and when the dancer is performing a series of synchronized foot-steps in a solo, the others wait while keeping the rhythm until there is a traditional signal for a change or a stop.

Since Compás is fundamental to rhythmic flamenco, in its absence, the compás can be produced through hand clapping (palmas) or by hitting a table with the knuckles to establish the timing, the frame of the piece. Knuckles are commonly used to

produce compas in juergas during cante. The guitarist can also use techniques to just establish time such as strumming (rasgueado) or tapping the soundboard. Dancers use their feet or fingers (pitos) to create percussion as well.

FLAMENCO RHYTHMS OR PALOS

The palos are the various forms or styles of flamenco. Palo literally means "stick". In its most primitive form, flamenco was accompanied by the tapping of a stick or cane in a characteristic rhythmic pattern, so that asking for a particular "stick" was synonymous with asking for a specific rhythm, and later for a particular style. "A palo seco" (literally "dry stick") is singing or dancing unaccompanied by instruments except for the rhythmic beating of a stick to frame the melody.

Flamenco Palos are different music styles. There are more than 50 different ones although some of them are rarely known or performed; also, not all palos are danced. They are classified mainly based on rhythmic pattern or place of origin however there are other considerations. There are many different traditional understandings within Flamencos that differentiate palos. Some palos are traditionally performed by men, and others by women; and some palos are performed by either sex. Some are mostly performed as solos while others are preferred to be performed by groups of dancers. Some flamenco artists are known for

specializing in a single flamenco form. Then there is the classification based on type of cante as mentioned before; the cante jondo, cante intermedio, and the cante chico.

Based on rhythmic pattern and also origin we will generally classify some of the palos as follows:

Toná (Also known as Cantes a palo seco)
Debla, Martinetes, Carceleras, Saetas, Tonás, and Trilla

Soleá Rhythm

These palos are the Solea, Alboreá, Bulerías, Cantiñas, Alegrías, Caracoles, Mirabrás, Romeras, Peteneras, Romances, Caña and Polo, Soleá, and Bulerías por Soleá.

Seguiriya Rhythm
These palos are the Siguiriyas, Cabales, Livianas, and the Serrana

Fandango Rhythm
These palos include the Fandangos de Huelva, Fandangos orientales from Eastern Andalusia and Murcia, Fandangos abandolaos which include the Verdiales, Rondeñas, and Jaberas, Fandangos libres which are free of rhythmic pattern, the Granaínas, Media Granaína, Malagueñas, Cantes de las minas which are songs originated in the mining areas such as the Minera, Tarantos, Tarantas, Cartageneras,

Murciana, Levantica, Cantes de madrugá, and the Fandangos personales which are personally improvised.

Tango rhythm

These palos are the Tangos, Tientos, Tanguillos, Zambra, Tarantas, and also include the Farruca, Garrotín, Marianas, and Zambra Mora.

"Ida y vuelta"

These also have a tango rhythm but since they originated in Latin America they are generally classified apart from the Tangos rhythm. They are the Colombianas, Guajiras, Milonga, Rumba, and Vidalitas

Other popular Palos are just classified under Andalucian Folk Songs

Campanilleros, Bambera, Sevillanas, Nanas, Zorongo, and others that don't fall under any other classification.

Universal Flamenco

FLAMENCO FAMILY TREE

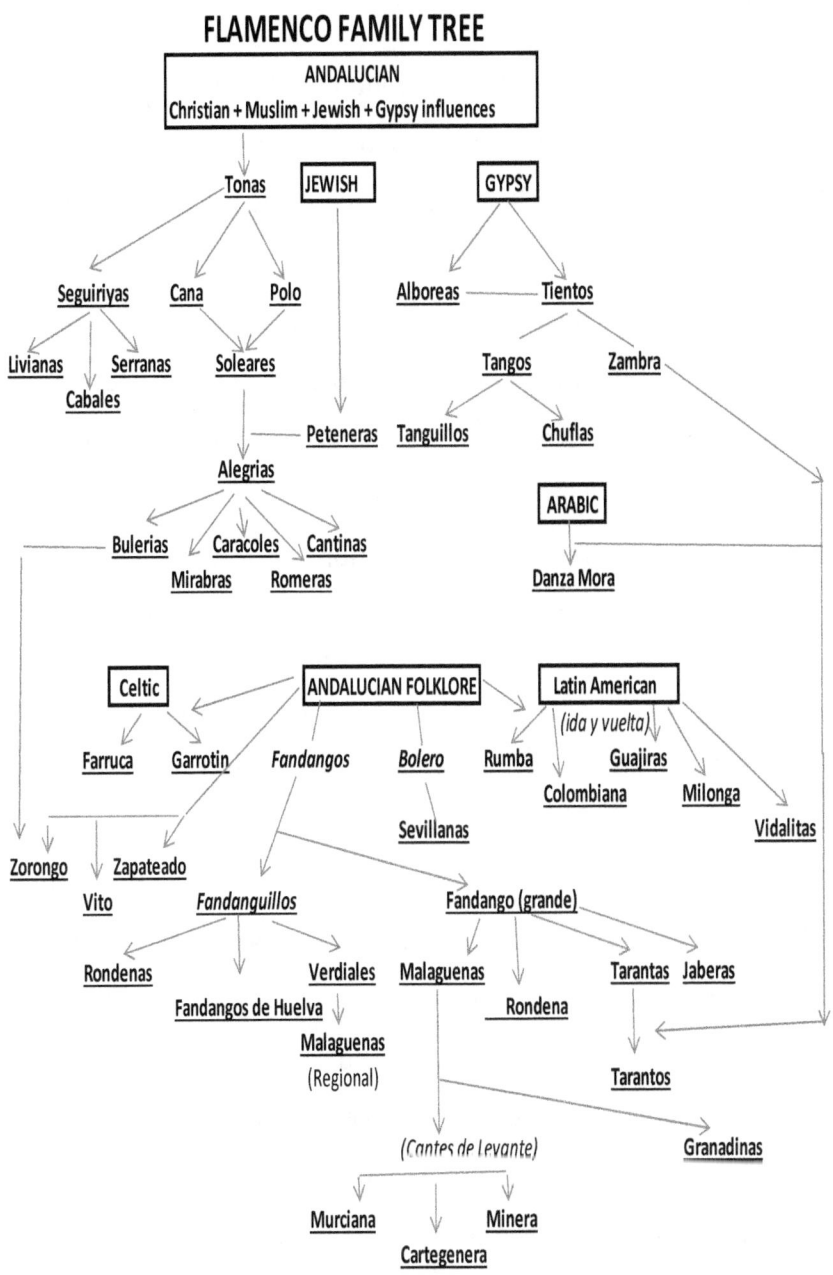

TABLAO FLAMENCO

In 1842, Silverio Franconetti founded the first café cantante. The Café cantante establishments known now-a-days as "tablaos" were places where Flamenco aficionados could enjoy tapas and drinks as well as a Flamenco show. It featured Flamenco singing, dancing and music on a regular schedule to cover the demands of an increasing interested audience. Soon, other café cantantes sprang in other areas of Andalusia and eventually other areas of Spain. Academies for the teaching of Flamenco also emerged as more of these establishments opened and sophistication was in demand. Today, there are more Flamenco academies in Japan than there are in Spain!

The idea of the Café cantantes provided gypsies and those that learned the art-form a way to make a living for the first time. However, they also served to commercialize the authentic art and to further influence other music eventually creating many fusions of the style. Several flamenco aficionados as well as intellectuals, including Poet Federico Garcia Lorca and composer Manuel de Falla, promoted traditional flamenco out of concern that the original styles of the art-form would eventually vanish. They devised a way of restoring and keeping the traditional purity of flamenco by organizing traditional flamenco competitions to conserve the authentic roots. As a consequence of the creation of competitive

events, Flamenco was exalted and promoted to a sophisticated urban audience that enjoyed its tradition, depth, as well as its complexity. This effort to maintain traditional Flamenco also helped the development of the art to what we know more of today.

Flamenco is like champagne, a rare taste that grows on you in enjoyment and understanding, a culture, and a philosophy of life.

During the last few decades of the 20th century and up to now, flamenco has been influenced in general, and new fusion styles have emerged; however, it is not difficult to distinguish between the traditionalist and the modern Flamenco.

A tablao, literal meaning a floorboard, is the name that replaced the Café Cantante. They developed during the 20th century with the same concept of featuring flamenco performers on a regular basis. The tablaos are usually decorated with posters of Flamenco artists. They mostly aim to convey an intimate feeling as they tend to be smaller rooms with tables and chairs fixed in front of a wooden stage. The decoration of some tablaos is sometimes made to resemble the Sacramonte caves.

Sacromonte is a hill in an old Arabic quarter of Granada populated by gypsy neighborhoods. The rock structure in this area is a mixture of clay and round pebbles which are soft enough to

excavate and cohesive and stable enough to form the walls of a cave. Consequently, most of the dwellings in this area are caves.

Some of the best flamenco performers that lived in the area turned their homes, which were in caves, into public places where people could visit to hear and see flamenco in its natural habitat. Later, these caves became more comfortable and appealing with electricity and modern plumbing to attract more visitors. The caves were usually named after the artists who performed in them such as Lola Medina, el Pitilin, Manolo Amaya, la Golondrina, la Faraona, and María la Canastera. In many cases the artists raised their families and lived in these caves; therefore, it was and is customary to find that all in a gypsy family were extremely gifted flamenco artists.

Despite their humble origins, the caves of Sacromonte achieved international fame and they were visited by many artists from Hollywood, Nobel Prize winners, famous politicians and even members of royal families as well as flamenco enthusiasts from all over the world.

A typical Flamenco stage consists of the stage itself; on it, armless chairs for the guitar players; and extra chairs for the dance performers who usually sit and clap their hands, doing palmas, while guitarists perform solos, and, or, other dancers perform on the state. It is customary to see the show start with a group dance

such as a Fandangos de Huelva, or Sevillanas; followed by dance solos by each of the dances sitting on the stage. Guitar players may also have a moment in the spotlight as they can also perform solos pieces. The last part of the show will be the main dancer's solo, followed by a finale group dance which could be several displays of dancing (or desplantes) in palos as bulerias, tangos or rumbas.

Guitarists Manolo Vargas, Tony Arnold, Roberto Verdi, and percussionist Jay Burnhand Performing at Workplay in Birmingham, Alabama.

MOST POPULAR FLAMENCO PALOS IN TABLAOS

The most popular Flamenco Palos performed now-a-days in Tablaos around the world are the Solea, Alegria, Siguiriya, Fandango, Tiento, Tango, Rumba, Farruca, and Sevillanas.

The Soleá

The Solea (soleares in plural) is a cante jondo and is called the "mother of palos." It is one of the most basic forms or "palos" of Flamenco music. It's prestigious and popular in tablao dancing as well as in singing competitions. Its origin is not really known but it is said it originated within the gypsy areas around Cádiz and Seville, in Andalusia, which is in the south of Spain.

Even though the solea is an old palo, it is said to be relatively new compared to the Tonas and the Siguiriyas, which are those cantes that resemble the Gregorian chants. The Solea was first mentioned by name by the Spanish poet Gustavo Adolfo Becquer in 1862 as "soledades" meaning loneliness and reflecting a feeling of separation, loneliness and sadness depending on the story being told. Some Flamencologists (those that study Flamenco) believe solea is the oldest and it is really the origin of all other palos.

Solea's popularity grew during the last part of the 19th century with the opening of the café cantantes all over Spain because a lot of the solea melodies are attributed to singers of that time. Today, the Solea continues to be one of the preferred palos for dancers performing solos.

During the 50s-70s, singer (cantaor) Antonio Mairena and other traditional singers of the time exalted the Solea as the palo with the

highest number of traditional songs. The solea is particularly appreciated by a knowledgeable audience and Flamenco fans for its complexity and demand on the singers to strive to maintain control among the melody, rhythmic patterns, and voice pitches; and at the same time, they have to be creative and improvise.

This palo demands great vocal faculties, and balance between passion and restraint for control since it includes techniques such as the singing of a single syllable of text while moving between several different notes in succession; this is referred to as melisma. Another technique used is microtones which are intervals of less than an equally spaced semitone. As we are mentioning all these techniques, have in mind that the Flamenco singers usually learn to do all this as growing up in the culture since it's an art-form mainly taught from generation to generation in gypsy camps or villas; therefore, Flamenco becomes natural to most of those who are born within these gypsy families.

Some Flamenco artists have contributed to the awareness of the art-form by commercializing it to attract audiences, and for increased financial support. Although popular for dancing, the Solea became less popular for singing solos for commercial purposes because it's a palo that requires the appreciation of a knowledgeable audience; an audience already familiar with the art-form and its complexities.

Camarón de la Isla, one of the best and most widely recognized Flamenco singers of the new Flamenco generation, and others that followed him, focused less on traditional styles or cante jondo like solea in his commercial productions. He emphasized other "palos" such as Bulerías or tangos which are easier to mix with pop and more appealing to an unfamiliar audience.

The different melodies known as in the Solea palo are not named using specific criteria. Some are named after the geographical origin, others after the singer who is believed to have developed it or popularized it; remember that a lot within Flamenco is just passed on from word of mouth, a lot is also just improvised or "made up."

If you want to do some research to appreciate the similarities and differences between the different types of Soleares, research online the following different styles:

Soleares de Triana sang by El Chocolate
Soleares de Cordoba sang by El Fosforito
Soleares de Alcala sang by Antonio Mairena
Soleares de Cadiz sang by Camaron de la Isla
Soleares de Jerez sang by Tia Anica
Soleares de Lebrija sang by Manuel Carmona
Soleares de Utrera sang by Fernanda de Utrera

Universal Flamenco

Children performing with Corazon Flamenco

The Solea uses the Basic Compas

The basic compas of 12 beats usually has strong emphasis on the numbers 3, 6, 8, 10, and 12 as per the illustration below. The rhythm usually ends at the number 10 where there is a break; a break is called corte in Flamenco talk; meaning this is where the music stops.

The Basic Palma accents are highlighted as follows:

1 2 3 4 5 6 7 8 9 10 11 12

Solea Metre (compás) and palmas

The metre or "compás" of the soleá is one of the most widely used in Flamenco; As seen in the Flamenco family tree, other palos have derived their compás from the soleá, including Bulerías por soleá, the palos in the Cantiñas group, like Alegrías, Romeras, Mirabrás, Caracoles or, and the Bulerías. It consists of the basic 12 beats, and could be described as a combination of triple and duple beat bars, so it's a polymetre form, with strong beats at the end of each bar. The solea pattern is the basic compass.

1	2	3	4	5	6	7	8	9	10	11	12
*	*	*	*	*	*	*	*	*	*	*	*
	■			■			■		■		■

Each number is a beat. Dark squares mean beats that are accentuated, while the empty squares are the regular beats without the accents.

Universal Flamenco

These regular beats without the accent can be sounded in claps, palmas, as in the following illustration:

1	2	3	4	5	6	7	8	9	10	11	12
*	*	*	*	*	*	*	*	*	*	*	*

The softer highlighted squares mean soft palmas, or where palmas can be left out entirely while keeping the rhythm in your mind as in the first illustration.

Therefore, we can use either pattern to do the palmas sounding all the beats with stronger emphasis on the darker squares under numbers 3, 6, 8, 10, & 12 or leaving out entirely the squares not accentuated.

Another common Palmas combination is the following:

1	2	3	4	5	6	7	8	9		10	11	12
*	*	*	*	*	*	*	*	*		*	*	*

Where the light squares are the soft palmas, as mentioned above, notice a half in between beats 9 & 10 (or contra beat)

Also notice that even though number 6 is supposed to be a strong beat, sometimes it is not accentuated in palmas as in the illustration above, this makes a sound beat variation. This happens mostly when there is no dancing to soften the percussion sound and give more focus on the actual singing and playing of the piece. As soon as the dancer starts the footwork, then the palmas will increase in strength and the accents will vary according to these general guidelines. At times, during the end of a dancer's footwork, no specific accent is made. The same happens when other palos related to the Solea such as Alegrias or Bulerias por solea are played. There are many patterns for palmas that increase in complexity.

When there are two or more people playing palmas, one of them usually plays a base pattern, emphasizing the regular beats, while another plays the beats in between the numbers which are called the contra beats or the contra tiempo mentioned earlier in the book.

The tempo in soleá can vary in speed but a traditional slower tempo will be required when it's being performed for dancing.

How to create your solea dance:

Start with an introduction known as the "entrada", the singer can do a full introductory cante (letra) or just a few words before

Universal Flamenco

you do an initial "llamada" or corte (break.) Then the singer can "tell the story" as these are areas where "pellizcos" (accents) with footwork can be introduced. Pellizcos are short spontaneous gestures, mimicries or whimsical movements employed by a dancer to heighten the effect of a dance. Literally, pellizco means a pinch, nip, or small bit, and the phrase is used in flamenco to describe actions which are spicy. These actions can also be saucy, juicy, flirtatious, or light humorous when they are not used in a cante jondo where the feeling is serious and dramatic.

While the focus is on the singer, do some paseos (walkthroughs) with braceos, or whatever movement the story compels you to show in form. The guitarist may follow the singer with a falseta (melody); let then the focus be on the guitar before starting any zapateado, or escobilla which is the footwork.

This sequence should be repeated a couple of times in a "traditional" solea pattern before doing a long zapateado which is an extended footwork increasing momentum before a last corte. After the last corte or llamada, the palo is usually switched to a more festive solea por Bulerias or Bulerias where the rhythm frequency is faster before ending the dance either by doing a final break or leaving the stage while keeping the rhythm. If the dancer chooses to leave the stage before the song ends, then the guitarist and singer with the palmeros will end it.

Even though the ending is festive and lighter, the mood of the solea is sad, maybe tragic, and the lighting should be deemed. Remember it is a cante jondo, so the theme of the song will probably be one of pain, tragedy, or forbidden love. The dressing should reflect the mood as well; therefore, dark colors are more appropriate and should be worn. The face expression and movements should also reflect the sadness associated with the theme as the dancer is telling the story in form as well and channeling the feelings convey by the song.

See a solea danced by el Faiquillo.

Alegrias

Alegrias means joys or happiness and originated in Cadiz. This palo belongs to the group of solea. It is categorized as a cante chico and characterized for its lighter themes. In dance, the Alegrias speed is animated and lively while a slower speed is used when only singing.

Alegrias Palmas

The Alegrias palmas begin on the 12th beat although many guitar and vocal phrases begin on beat 1. As in the most basic compas structure there are five accented claps sounded within the 12-beat frame. The numbers 12, 3, 7, 8, 10 represent accents in the claps with the remaining seven beats clapped softly.

Universal Flamenco

To practice, count the numbers (beginning from beat 12) while clapping accented and non-accented strokes. Use both sordas and claras palmas (hand clapping) techniques. With practice over time, this unusual "12 equals 1" phraseology—where 12 is the first beat of the cycle—will become comfortable—and even natural.

11	12	1	2	3	4	5	6	7	8	9	10
*	*	*	*	*	*	*	*	*	*	*	*

or

11	12	1	2	3	4	5	6	7	8	9	10
*	*	*	*	*	*	*	*	*	*	*	*

Beat 10 is a critical cadence point where the dance and music end their phrases together in a dynamic fashion. As mentioned before, this is the number where the "corte" or sharp end happens. Beat 11 is dramatic in its musical silence and statuesque pose in dance. The music and dance resume at beat 12 and continue the cycle to another corte in 10. When the guitar initially begins to play Alegrias and before the cante, the palmas should start around the 7.5 beat giving it a gradual variety of sound to the piece.

A difference of the Alegrias in comparison to other palos is that its pattern is very strict and defined. The traditional alegrias dance must follow a specific order as described below. Use the following as a checklist.

How to create your own Alegrias dance:

An entrance or "salida" should be used to start the dance. This is an introduction. The dancer could just let the singer do some singing at the beginning before a corte, or just start dancing with the singing following the order as described in the following pages.

Start with a Paseo which is a walk around, using the arms and torso movements, and making pellizcos to accent the singing. After the Paseo, do a break and follow with a Silencio. A silencio is similar to an adagio in ballet.

See my silencio on youtube under Irene Rimer Alegrias Silencio.

Following the Silencio, start a part of the alegrias named the castellana. A castellana is an upbeat section done between the silencio of the Alegrias and the footwork of about four cycles of rhythm.

After the Castellana comes an escobilla or zapateado (footwork) which creates a momentum of percussion within the dance that is

Universal Flamenco

very exciting to watch. After the Escobilla do a corte to end the Alegrias; follow with a Bulerias desplantes to end the dance.

An ending in Bulerias takes the rhythm to a faster speed before the end of the performance. When there is no dancing, this pattern for the Alegria is not followed, and there is more freedom in the combination of palos with others of similar origin such as the cantiñas and Romeras.

The mood of the Alegrias is as its name indicates, happy. Dresses should be festive and colorful. The face expression should tell the story of the theme and the speed is faster indicating animation.

See Eva La Yerbabuena in youtube dancing Alegrias.

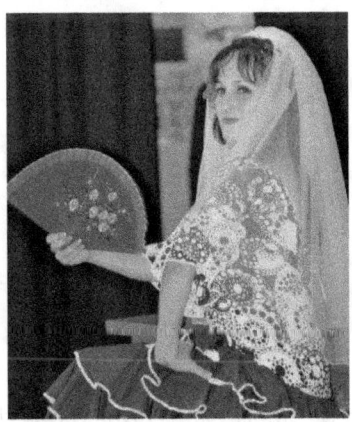

Irene Rimer performing Alegrias using a fan as a prop. Another prop that can be used is a shawl.

Bulerías

Buleria, or Bulerias in plural, is exciting and one of the preferred palos in juergas. It originated in Jerez around the 19th century to be used at the end of other Flamenco palo dances such as Solea or Alegrias which have the same rhythmic patterns at slower speeds.

The term bulerias comes from the Spanish word burlar meaning to mock. It's a playful ending to several rigid dance forms, and it gives a lot of improvisational freedom. A control of the rhythm is required for guitar, singing, and dancing which include intricate tapping with toe, heel, and the ball of the foot combinations (similar to tap dancing but with a totally different foot-work technique.)

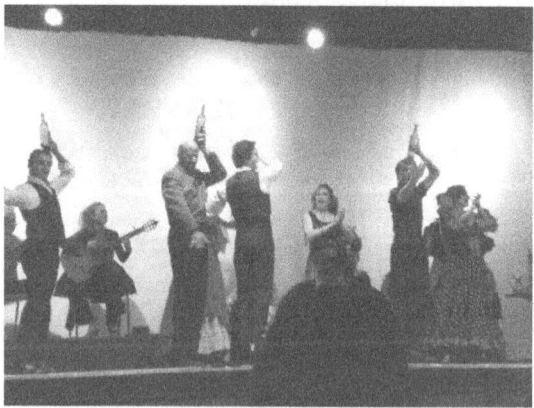

Corazon Flamenco male dancers performing Bulerias with wine bottles on their heads.

Universal Flamenco

Bulerias basic palmas or clapping pattern is as the basic compas but much faster:

1	2	3	4	5	6	7	8	9	10	11	12
*	*	*	*	*	*	*	*	*	*	*	*

The same as in the Alegrias:

11	12	1	2	3	4	5	6	7	8	9	10
*	*	*	*	*	*	*	*	*	*	*	*

Or during some cante, illustrated as a fraction of 12 in 6 beats:

1	2	3	1	2	3
*	*	*	*	*	*

As mentioned, Bulerias are used as upbeat endings to palos with Solea compas. Therefore, the face expressions and dressing will be according to the mood in the cante of the performance. If dancing a Solea where the theme is sad, the ending can change the tone to a happier one with a lighter letra, or even moking to change the mood at the end as if conveying to the audience that the theme was just a sad story, but now this is the end of the story, and "time

to play," and have fun time. This can be very philosophical and emotionally healing because this attitude really carries a positive message of no matter what the life circumstances are, we must look up and dance. Besides the Bulerias, we have variations like the Solea por bulerias which is in the Solea rhythm resembling the Solea melody at a faster speed.

See maestro el Guito in Solea por bulerias on youtube. This is this performer's signature palo.

Siguiriyas

Siguiriyas or Seguidillas is a cante jondo as the Solea with dark and mournful themes of persecution, injustice, pain, forbidden love, and death. The word sigiriyas may be a gypsy dialect variation of the word Seguidilla, a classical Castilian folk dance. It's also often written as Seguirillas.

Traditionally, Siguiriyas was considered not appropriate for dancing and was mostly sung during processions and in funerals as it reflects grief and deep pain. Its mood is considered sacred and mostly for cante as its one of the styles that most closely resembles the Gregorian chant. It is said to be the greatest test of a singer's ability, and the most profoundly emotional of the flamenco repertoire.

Universal Flamenco

In the same meter of 12 beat-counts the emphasis is placed differently within the Siguiriyas melody. It begins on the 12th beat with emphasis on 1, 3, 5, 8, and 11. It is also taught as three fast beats alternating with two slow. Since the rhythmic structure and traditional playing key is the same as Buleria, it is possible to perform Siguiryias por bulerias, however this combination is considered by some to be an unacceptable corruption of the more serious form. Therefore Bulerias is usually an ending for any palo in the Solea rhythm but not for Siguiriyas.

Siguiriyas compas is of 12 counts as well with the emphasis on numbers 1, 3, 5, 8 and 11 as shown below:

12	1	2	3	4	5	6	7	8	9	10	11
*	*	*	*	*	*	*	*	*	*	*	*

As you can see, even though Siguiriyas has the same measure as the Soleares, Alegrias and Bulerias, the accents are different. Based on the emphasis on the numbers this can be seen as a combination of shorter measures when simplifying it.

For example

y	1	y	2	y	3	1	2	3	4	5	6
*	*	*	*	*	*	*	*	*	*	*	*

See La Tania dancing Siguiriyas

Fandangos

Fandangos were extremely popular folkloric dances in large areas of Spain in the 18th century. It is said to have been derived from the Jota, a Spanish dance from the area of Aragon, with a triple meter, performed by a couple, and marked by complex rhythms executed with the heels while playing castanets.

It was at the end of the 19th century that the Fandangos transcended the folkloric environment and became a Flamenco palo. Fandangos can be sung as cantes libres without the rhythmic frame and they can also be sung and played to support Flamenco dance. Almost every region of Andalusia has its own version of fandangos; when played for dancing the rhythm follows a 3/4 or 6/8 meter.

Fandangos Classification

Fandangos de Huelva.

The Fandangos de Huelva emerged from the province of Huelva as the name states; their traditional styles are rhythmic, but since the beginning of the 20th century they have also been interpreted as cantes libres, or a mixture of cante libre with rhythm. Most personal creations by singers which are called Fandangos personales (personal Fandangos) are mixed. The variety of traditional local fandangos in the province of Huelva is enormous.

Fandangos orientales (eastern Fandangos) originated in the eastern part of Andalusia and Murcia. This subgroup is further classified as:

Fandangos abandolaos. They are played in regular 3/4 time signature. They include Verdiales, Jaberas, Rondenas, Fandangos de lucena, old Malaguenas and other palos.

Fandangos Libres which have no regular rhythmic pattern and include modern Malaguenas, Tarantas, Cartageneras, Cantes de Madruga, Mineras, Mucianas, Levantica, Granaina and "Media Granaína".

Fandangos personales which are any fandango that is not traditional by a creation of a more recent singer were the

predominant flamenco song between the 30s and 50s of the 20th century.

Fandango can both be sung and danced. Sung Fandango is usually bipartite: it has an instrumental introduction followed by variations (variaciones). It usually follows the structure of "cante" that consist of four or five octosyllabic verses (coplas) or musical phrases (tercios). Occasionally, the first copla is repeated.

Fandango grande are referred to a song form, cante jondo, with toque libre. It's an abstract song form which evolved as a serious version of the original Fandangos and is sung without compás. This song form may also be referred to as Fandango naturales (natural Fandango.) Most of the toque libre are derived from Fandango Grande.

Fandanguillos (meaning little Fandangos) is a cante and toque chico with mixed baile. The term is a 'group' name for the regional styles of festive Fandangos. These include the Fandango de Lucena, and Fandango de Almeria. Verdiales, which could also be called Fandangos de Málaga by the same naming system, are also Fandaguillos by definition. They can be performed with a variety of instruments, including violins, tambourines, castanets, reed flutes, partially-split canes, and drums.

Universal Flamenco

Each village in Huelva has developed its own Fandanguillos. The huge popularity of this form during the first three quarters of the 20th century has only recently subsided.

Palmas for Fandangos are done to the compas of 3, although the complete melody follows a pattern of 12 counts. Therefore below you'll see four times 3.

1	2	3	1	2	3	1	2	3	1	2	3
*	*	*	*	*	*	*	*	*	*	*	*

For the basic Fandangos palmas place the accents in number 1 as shown by the dark squares, then soft palmas in the rest of the numbers.

1	2	3	1	2	3	1	2	3	1	2	3
*	*	*	*	*	*	*	*	*	*	*	*

Also, as above, place the accents in number 1, then 1 and 2, leaving the space on the subsequent number 3 silent and then continuing the pattern of twelve for an entire cycle.

Fandangos are majestic and usually happy. For dancing, they are mostly used at the beginning of a performance. The entrance could be done with either a corte or llamada (break) or by dancing the copla as the singer tells the story; footwork accents, pellizcos, can be used during this time. Footwork can be incorporated in between a couple of coplas before the Fandango ends when the rhythm speeds up gaining momentum with footwork or palmas before a final corte.

Tiento, Tango, and Rumba Flamenca

Tiento is a slow Tango with a solemn feel to it. This form appeared between the 19th and 20th century; however I wouldn't be surprised its origin is farther back as it is also a form of cante jondo meaning touch or to tempt. It is said that if Solea is the mother of flamenco, then Tiento is the father.

The Tiento is usually notated in 2 sets of 4. It's of a majestic, enchanting, and sensual character as it is normally played in the A Phrygian mode. Although the compás is the same as Tangos, Tientos are slower having some beats that are prolonged and others are cut short. This can look messy and confusing in music notation. The best way to learn the compás of Tientos is by listening.

Tango is closely related in form and feeling to the more popular Flamenco Rumba. It's an animated baile chico dance in a frame of 4/4 with a compas length of 8 beats, usually in phrases of 4 compas cycles each. Although it is generally performed in a light style, it has an insistent, yet subtle tone of seriousness about it. Tangos are different from Rumbas in its accents and tend to be slower in speed.

Tangos are to Tientos what Bulerias are to Soleares or Alegrias as they are often performed as endings to a Flamenco Tiento or Taranto. Its compass and corte are the same as that of the Farruca; however the Tango is performed in a Phrygian mode.

The Flamenco Tango has vague similarities to the Argentine Tango as they share a compas binario or double stroke rhythm. Some musicologists believe they have a connection, perhaps through a common ancestor. Some emphatically insist however that the Flamenco Tango is of purely gypsy origin, having distinct similarities to the Tientos. Also, arguments about whether Tientos came before Tangos or vice versa are best left to musicologists and purists since they often disagree. No one seems to really know.

Rumba Flamenca is also called Gypsy Rumba, Spanish Rumba, or simply Rumba, and is a style of flamenco music from Spain with strong Latin American influence, mostly from Cuba. This palo has

the Tango rhythm however it is categorized differently as it is known as a palo of "ida y vuelta" (return songs) because it was music which was modified in the new world after the discovery of America, and then returned to Spain with a new "feel", that included new melodies.

In Latin America this style of music was performed with congas or related percussion instruments influenced by the Afro-Cuban Rumba. The dance was very sensual encouraging improvisational moves. When the new style made it back to Spain, it was adapted to the playing of the guitar and hand-clapping of flamenco.

Modern Flamenco guitarists such as Paco de Lucia have now incorporated cajon and other percussion instruments to add the tropical feeling to the music.

Palmas for Tientos, Tangos and Rumbas

Follow the Palma patters in the illustrations below making stronger emphasis on the numbers above the dark cells and less above the light cells. Where a cell is white, the palmas should be omitted. The speed will depend on whether we are clapping for a Tientos, a Tangos, or a Rumba.

1	2	3	4	1	2	3	4
*	*	*	*	*	*	*	

1	2	3	4	1	2	3	4
*	*	*	*	*	*	*	

Zambra

It is probably a good idea to mention the Zambra here although it is not a palo popularly danced in tablaos. The zambra has a Tango rhythm and is regularly danced at gypsy weddings and celebrations. It is also known as the Zambra Mora. It is believed to have evolved from earlier Moorish dances and has some similarities to belly dancing. In Maghrebi Arabic spoken in Morocco, zambra means "party". Gypsies perform it for tourists in the Sacromonte cave houses in Granada.

The Zambra was outlawed at one time in history and became known as the "Forbidden Dance" for its sensual style. Later, it was espoused by flamenco dancers Carmen Amaya, La Chunga, and Pilar Lopez. It is danced by women barefoot with finger cymbals; the

blouse is tied under the bust and the skirt is usually tight around the hips, then flares out and has a ruffle at the end.

Farruca

Farruca is a cante chico traditionally only danced by men in 4/4 compas. It is believed to be originally a song from the northern region of Galicia or Asturia that was adopted and modified by the Andalusia gypsies; some say it was invented by a dancer named Faico. The word means a gypsy term for a Galician living away from home in Andalusia. The Farruca is usually played in the key of A minor with each compas equivalent to 2 measures of 4/4 time as a tango but with different emphasis.

Although the rhythm is strong and strictly defined, some passages begin slowly and gradually build speed, especially in the finale. Although this form is considered a man's dance, women perform it wearing male clothing. It is generally not sung by purists.

For a dance or as a guitar solo (solo sometimes played in E minor), it is a very dramatic piece. The dance is characterized with fast turns and fast intense zapateado; also held lifts and falls, and dramatic poses.

See Farruca by Irene Rimer

Palmas for Farruca

1	2	3	4	1	2	3	4
*	*	*	*	*	*	*	*

Notice the first beat left black, with the strongest emphasis on number 4.

1	2	3	4	1	2	3	4
*	*	*	*	*	*	*	*

Also use the pattern as above but putting a little more emphasis on 2.

Sevillanas

Sevillanas is a folk type of music and dance of Sevilla. The Sevillanas are a group of four dances known as coplas danced with partners adapted to Flamenco during the 19th century from the Seguidillas Boleras, an old Castilian folk music and dance genre derived from the dance form known as Seguidillas Manchegas which were popular in the Castilian region of La Mancha.

The Sevillanas pattern is elementary and limited however there are numerous melodies and lyrics to them based on every day mostly happy life themes. They are very festive and popular in the Andalusia festivals, such as the well-known Fair of Seville where they are played and danced all day long. The dance is widely taught and it is customary to see almost all the population learning to dance it; mainly so that they can be ready to dance at the recurring festivals all over the Andalusia region where tents and wooden stages are set for dancing mostly Sevillanas.

Within each copla of the Sevillanas there is a melodic theme which is usually sung (or played) three times and begins with a characteristic Sevillanas step. The four coplas each ends with a sudden stop as the dancers strike a pose. Guitarists performing it without a singer often play each of the 4 sections in a different key with a different melody.

There are several styles of Sevillanas, including boleras, corraleras, and rocieras. The names as well as the steps associated with the four coplas of Sevillanas tell a story of courtship. The first, "El Encuentro" is the meeting, with ritual bows. This is the initial flirting stage of a couple that like each other. The second is "La Seduccion", with the partners passing each other repeatedly insinuating they are seducing each other. The third, "La Pelea" is the fight, with some foot stamping as if asking and responding to

each other, and the fourth is the reconciliation or "La Reconciliacion".

Palmas for Sevillanas

1	2	3	4	5	6
*	*	*	*	*	*
▓			▓		

Also remember you do not necessarily need to sound the solf palmas.

1	2	3	4	5	6
*	*	*	*	*	*
▓			▓		

FLAMENCO OUTSIDE OF SPAIN

Flamenco has enchanted people from all over the world. It is said that once the "bug" of Flamenco bites a person, the person will be hooked to the art-form for life. Tablaos became popular all over the world, and Flamenco artists have had the opportunity of travelling to perform or moving to teach the art-form outside of Spain.

There are Flamenco festivals resembling those held in Spain such as the Flamenco festival of Albuquerque, or Miami. These festivals usually feature Flamenco performers from Spain as well as local Flamenco groups. There are also large gypsy communities all over the world that continue their traditions and frequent the tablaos.

Flamenco has become universal in its own right, and its influence is expanding. Great performers have emerged from other countries such as Argentina, Peru, Colombia, Venezuela, Japan, Germany, Israel, and many others. Today, there are Flamenco schools all over the world. Famous Flamenco artists are able to do tours performing and teaching as demand increases.

One of the many good attributes of Flamenco is that it can be performed at any age. Dancers usually reach their peak at age thirty and continue performing well beyond the age of 50. It's an art-form of a life time for guitarists, singers, and dancers. Flamenco is a philosophy, a way of expression, a way of life, and a great way to party.

Since Flamenco is one of the best examples of emotional mathematics, this writer advocates the acquisition of rhythmic precision through its teaching in order to achive alignment with the universal law of rhythm from which all can benefit in all areas of life.

Universal Flamenco

Corazon Flamenco is a professional Flamenco troupe formed in Alabama by this writer, the group's goal is the entertainment and education of audiences in the art and culture of Flamenco, the art of the gypsies, by offering an annual professional performance with guest musicians from surrounding areas and from Spain at a variety of venues, offering lectures on the origins and roots of Flamenco focusing on schools and universities, teaching dance workshops that include the different rhythms of Flamenco, and teaching regular classes for all levels. Dancers and musicians in the troupe include people from different countries and states that share the same passion for Flamenco.

In 2014, this writer moved to Florida and continues to perform and teach in the Tampa Bay area—Dunedin, Sarasota, and Port, Charlotte. Guitarist Tony Arnold and his wife Jill moved from Tallahassee to the Tampa Bay area as well to continue working with Irene Rimer, and the new troupe of Flamenco artists that seem to come out of nowhere to enjoy Flamenco. If you are ever in the area and wish to learn or perform with us, please email me at info@irenerimer.com

Don't miss the continuation of this book in *The Gypsies, Keepers of the Mysteries. Flamenco and Tarot.* Book available at amazon.com

Picture by Leah Paxton

ADDITIONAL FLAMENCO VOCABULARY

Contributed by guitarist Tony Arnold
This vocabulary is in addition and complementary to all rhythms and words explained in the book, and that may be of help to the reader.

A palo seco: Literally meaning "dry stick." It is unaccompanied singing and it's the most primitive cante. Compás was kept by the rhythmic beating of an upright stick on the ground, comparable to "*a capella*". Although the earliest flamenco was sung without instrumental accompaniment, the guitar has become such an integral part of the art form that unaccompanied singing is now usually reserved for only a few palos.

Aficionado: An enthusiast follower, a fan or amateur.

Aflamencao: "flamencoized".

Aire: Air. It describes the expressiveness, "feel", atmosphere or general character of a flamenco performance.

Alboreás: (Song and dance form) Alboreá is of pure gypsy origin, traditionally sung only at weddings, being unlucky on other occasions. It is a gypsy wedding song performed to the compás of Bulerias. Alba means daybreak or dawn. The name indicates that the songs were either literally sung at dawn, or symbolically represented the dawning of a new life. It is a relatively rarely heard

form as it is considered bad luck to sing it on any occasion other than a wedding.

"The word alba is also defined as a 'troubadour song or poem' of lovers' parting at dawn. Troubadours were 11th and 12th century poet-musicians of southern France. The German counterparts of the troubadours, the 'minnesingers', also used the form, calling it Tagelied (day song). The words Alboreá (singular) and Alboreás (plural) are commonly interchangeable and mean exactly the same thing."

Ambiente: Atmosphere or Ambiance

Andalucia: Region of southern Spain. It's the birthplace of Flamenco and consists of the eight provinces of Almeria, Cádiz, Cordoba, Granada, Huelva, Jaén, Málaga, and Sevilla.

Angel: soul in performance

Arranque: spontaneous outbursts of emotion that a performer may show.

Aretes: earrings, also called pendientes.

Aro: Aro means hoop. The name given to the (curved) side of the guitar.

Ay: Spanish exclamation that can express either sorrow/pain or happiness by the singer depending on the context.

Bailaor: or "bailao" as pronounced by gypsies is a male dancer

Bailaora: Female dancer

Baile – Dance: Dance class vocabulary might include the following:

Balanceo y vaiven: swaying of the body and hips. Balanceo is gentle; vaiven is more violent.

Bamberas: Andalucian folk song of medieval tradition which may be Celtic in origin. The name is taken from the words Bamba (swing: noun), Bambolear (swinging) and Bamboleo (to swing). This is one of the more obscure flamenco song forms, and is neither danced nor played, only sung. The words Bambera (singular) and Bamberas (plural) are commonly interchangeable and mean exactly the same thing.

Bata de cola: the full flamenco dance dress with long train (cola).

Boca: Mouth or the sound hole of the guitar.

Bolero: Although not considered Flamenco, the Bolero played an important part in the evolution of some of the more familiar dance forms. The word bolero comes from the verb volar (to fly). Jumps and leaps were an integral part of the dance as were paseo (walk) and parado (sudden stops). It developed into a set dance from a combination of folk and classical styles as well as the court dances of the late 18th century. One of the folk styles that influenced it was the old Fandangos. Another was the Siguidillas Manchegas, which also influenced the development of the Sevillanas. It goes without saying that Maurice Ravel was inspired by the Bolero to compose his famous orchestral version. The Flamenco composition Los Panaderos (the bread makers), by Esteban de Sanlucar, is a form of Bolero and has been recorded by Paco de Lucía, Juan Serrano and others. Carlos Montoya has also recorded a piece called Bolero.

Botas: high-topped boots, especially those worn with the traje corto or traje campero and in zapateado.

Botines: low-topped boots worn by male dancers.

Braceo: Movement of the arms during the dance.

Cabales: Flamenco experts. These individuals fall into a category beyond aficionado and can distinguish the various forms, tempo, beat pattern, and variations on styles. This is an Andalucian term for

someone with honor and respect. Also: a palo of the Siguiryia family, fast and rhythmic, usually at the finale of a Siguiryia.

Cadenas: Footwork combination in triplets, beginning with the golpe of one foot followed by the heel of the opposite foot and then returning to the beginning foot.

Caja: the body of a guitar.

Calo: Spanish Gypsy dialect, a hybrid blend of Romanes and Spanish. Much flamenco is sung in calo.

Cambio: Change. Usually refers to a change in an otherwise typical chord progression, or a change in style within the same palo.

Camisa rizada: ruffled shirt.

Campanas Bells: A musical section in Zapateado, which imitates the sound of bells.

Campanilleros: Bell ringers, and a form of cante and toque chico. Traditionally these are songs sung during religious processions that begin at dawn. They are accompanied by the ringing of small bells. The tradition of bell ringing is also connected with religious activities in monasteries. Campanilleros are not really flamenco but are nonetheless still sung and played by some artists as part of their repertoire. The words Campanillero (singular) and

Campanilleros (plural) are commonly interchangeable and mean exactly the same thing.

Caña: Caña, very closely related to Soleares, is one of the oldest forms of flamenco, and one of the most pure and beautiful. It usually has religious overtones and chant-like passages, which make it well suited to the misa flamenca. Pilar Lopez is usually credited with being the first to dance this form in the late 1940's. Also see Polo.

Canasteros: Gypsies. The literal translation would be "basket weavers", but the word implies membership in a family of "true" gypsies.

Cantaor: Singer

Cante: Singing

Cante flamenco: Flamenco song

Cantes de Levante: These are cantes from Granada, Jaen, Almeria, and Murcia.

Cantiñas: A family of song forms from Cádiz which include Alegrías, Romeras , Mirabrás , Rosas, and Caracoles. According to Donn Pohren, the word was originally used to describe medieval songs from Galicia, in Northern Spain. Today, its meaning is extended to signify popular song. The cantes listed above therefore,

are no longer referred to as Cantiñas (but by their specific names). The notable exception is Alegrías, which many cantaores and aficionados name Alegrías or Cantiñas interchangeably." It can be a little confusing when one considers that Cantiñas is also the name of a specific form of Alegrías played in the key of C, whereas Alegrías played in the key of A can sound quite different. Furthermore, Alegrías is the only one of this group that has a *silencio* section. Structurally, Cantiñas (the family of songs) are the same as Soleá, except for subdued accent on the count of 12. Depending on who you speak to, some consider this classification of these Alegrías style songs outdated and meaningless. It could be debated whether Alegrías is a generic name for a family of cantes which include Cantiñas -- or vice versa. In practical terms, the debate is irrelevant to the music.

Caña: (song and dance form; cante jondo) A song form, like the Polo, with exactly the same compás and accompaniment as Soleá. The only difference is its distinct Ay Ay Aye's (shared with the Polo) and the melodic line. The significance of Caña and Polo lies in the widely held theory that these early song forms may be ancestral to Soleá. There are also those who believe that the Caña and Polo came after Soleá. Their first appearance in literature, however, does predate that of Soleá, and includes an inference that they are of Arabic origin. Like Polo, only one form of Caña survives; it is

therefore appropriate to refer to them in the singular. Their formality and un-flamenco aire makes them poorly regarded by most aficionados.

Caracoles: (Song and dance form) One of the group of songs known as Cantiñas. Caracoles mean snails, which gives an indication of its light-hearted nature. It was developed in Cadiz in the mid 19th century, although it soon became strongly associated with Madrid. Curro Cuchares and El Tato, who worked in the bull-rings and were also good singers, took this style to Madrid where it became very popular. Later it was recreated in a masterly way by Antonio Chacon, who gave it its present brilliance and vitality. It is rhythmically identical to Alegrías, the main differences being the key (C Major), different chord sequences and nonsense verses.

Carceleras: Cante grande a palo seco. One of the oldest flamenco song forms, originating in the prisons of Andalucia. The cante describe the singer's loss of freedom and life in jail; a type of tonás.

Careos: a type of passing step used in the fourth copla of Sevillanas.

Cartageneras: (cante, toque libre) A Fandangos-like song (with a strong Moorish, not gypsy, influence) taking its name from the area of origin, Cartagena. One of the most recently-developed songs

known as Cante de Levante. It is believed to have evolved from the Tarantas in the late 19th century.

Chuflas: (Cante, baile, and toque chico) A humorous, even comical, form of tanguillos, with the emphasis on spontaneity and humor. Developed by the gypsies of the Cadiz area. Also a dance step: equivalent of a shuffle, when the foot lifts from behind, slides, and strikes the floor with a golpe while the other foot simultaneously slides along the floor.

Cierre: a llamada that closes of a section of song or dance.

Coletilla: a short form of *estribillo*. Literally, "little tail". Usually used by the singer to end a section. In alegrias, it is a verse of cante at the end of the main letra, usually lighter and more rhythmic.

Colombianas: (Song and dance form) A delightful song form based on the melodies and rhythms of Colombian folk music. This form was brought to prominence by Carmen Amaya and Sabicas. For those who like a good argument, it has been suggested that Colombianas, like Rumba and Guajiras, is a variation on the Argentinean Tango.

Colín: dress, like a bata de cola but with short train.

Contestacíon: A type of a *desplante*, literally means *an answer*. A section of dance executed during singer's *respiro*. After the singer finished the first line of a letra he/she traditionally may take a *respiro* (a break in singing, literally meaning *a breath*) and the dancer will use that time to *answer* the singer with strong visual/rhythmical progression usually involving footwork. Contestacíon is traditionally 1 compás in length but may be 2 or more depending on the dancer's preference. The concept can also be used between a guitarist and other performers.

Copla: A verse or stanza from a song. The word copla is also used to describe the sections of Sevillanas (usually four) and Fandangos.

Cordobes: From cordoba; also a flat-crowned wide-brimmed hat worn in Andalucia and often used with a flamenco costume.

Corte: a sudden stop by dancer, singer, or guitarist.

Cuadro: Group of flamenco performers, traditionally including dancers, singers, palmeros and guitarists, and in these "post Paco" times, can even include a bass guitar, cajon, flute, bongos, drums, violin, cello, or oud.

Debla: (cante a palo seco) Toná with religious overtones. Pohren mentions an outdated Calo letra making reference to a

"grand goddess" that suggests a connection to a long-forgotten gypsy ritual.

Desafinada: out of tune.

Desplante: a dancer's signal to the guitarist to link two parts of a performance, usually performed with a seris of foot stampings (golpes de pies)

Entrada: Entry or beginning, mostly of the dancer. See *salida*.

Escala: musical scale.

Falda: Skirt

Falseta: (lit., "flourish") A musical variation or passage played on the guitar. Always remembering that the original role of the flamenco guitar was as accompaniment, it is easy to understand how the falseta began as a short interlude or bridge (usually lasting no more than a few compas cycles) played between verses of cante or during breaks in dance, sometimes as a variation on a melodic theme established by the vocalist, or a rhythmic theme of the dancer. Not surprisingly, when the solo flamenco guitar began to find its place in public performance and in the concert hall, early solo flamenco guitar compositions often took the form of an elaborated and integrated series of falsetas. The concept of the

falseta remains at the core of flamenco guitar composition and performance, although "set piece" compositions have also become common. To the extent that the flamenco idiom can validly be described as improvisational, one must say that it is the strumming and rasgueado patterns that are more commonly improvised. The spontaneous invention of new falsetas, however, is rarely seen. Intead, one sees the spontaneous assemblage of pre-existing falsetas and falseta fragments that reflect the creative choices of the performers involved. For this reason, the experienced flamenco accompanist needs to have a large library of falsetas committed to memory for each palo.

Fiesta: Party

Figura: a star; a performer who has achieved name and fame.

Flamenco puro: also arte Flamenco puro; singing, dance, and guitar in the original Gypsy style, which was performed privately, and only later for a public audience.

Flamingo: A pretty pink bird whose only connection to Flamenco may be indirectly etymological. In the 15th or 16th century, Spanish explorers in the New World thought these colourful birds resembled colourfully-dressed Flemish gypsies known in Iberia as Flamencos, and so named the birds. Linguists generally believe that the same gypsies gave their name to the art

form. Other common mispronunciations are 'flaminco' and 'flamengo'.

Fleco: fringe, on shawl or manton.

Fusion: A merging of distinct elements into a unified whole

Gachó: Calo (Gypsy or Romany) word for non-Gypsy (compare *payo*).

Gallegadas: A traditional folk dance in the region of Galicia and Asturia in the north of Spain. This is not considered flamenco, although Sabicas, always an innovator, allowed this form into his guitar repertoire with the title *Piropo a Galicia*. Piropo means compliment or flattery. The dance is kept alive in local festivals of the region.

Garrotín: (Song and dance form) A sensuous and happy song and dance in 2/4 time. Like the Farruca, it originated in Northern Spain, and although sometimes considered folkloric by aficionados, it has gradually gained acceptance into the flamenco repertoire – perhaps under the influence of Vicente Escudero, who maintains it originated with gypsies of Lérida, in northern Spain. Also like the Farruca, it has slow sensuous sections, sudden stops and starts, and sections which start slow and build up to a furious pace.

Gesto: golpe of a guitarist. See *golpe*.

Gitana: Spanish name for female Gypsy

Gitano: Spanish name for male Gypsy

Golpeador: Tapping plate. Protective plastic (formerly hardwood or tortoise shell) sheet attached to the face of the guitar.

Golpe: The tapping on the top of the guitar, typically with the tip of the 'a' or 'am' fingers. In musical notation, the golpe is

Gracia: grace in a performer.

Granadinas: (Cante and toque intermedio and libre). The word implies 'something from Granada'. The name Granaínas, which is simply the Andalucian pronunciation of the same word, is also commonly used. Granadina is normally played in the B Phrygian mode, often resolving to E minor, which is ideal for producing the rich, oriental sounding passages that characterize this introspective flamenco form. It is a form of Fandangos grandes with strong Moorish influence. Media Granadina means 'half Granadina' and relates to the style of cante. For the solo guitarist there is no difference.

Grande: big, Important

Guajiras: (Song, toque, and dance chico) From guajiro, meaning "white Cuban farmer", a popular song that is common among them. This is an example of *cante de ida y vuelta* (q.v.), having a strong Cuban influence, reputedly dating from the time of the conquistadors. This happy and nostalgic song and dance form is normally played in the key of A major and notated with alternating measures of 6/8 and 3/4. The 12 beat compás is identical to Bulerias, but much slower. The melodic line usually begins on beat 12 of the Bulerias compas (12, 3, 6, 8, 10). Guajiras is one of the more uplifting flamenco forms and a classy showpiece in any solo guitarist's repertoire. Traditionally a woman's dance (guajira translates as "Cuban peasant girl"), it is almost always performed with a fan. The words Guajira (singular) and Guajiras (plural) are interchangeable and mean exactly the same thing. Several experts believe that this cante should actually be called punto cubano, as it existed in Cuba under this name before coming to Spain.

Guapa: A good looking woman

Guasa: joking in bad taste, rustic trickiness.

Gultarerro: A maker of guitars.

Improvisation: is always an issue for students of flamenco. In any art form, complete spontaneity is only possible for the soloist;

group improvisation can only take place within the guidelines that keep the group on the same path, whether it be the choice of a key and a meter in jazz, or the choice of a musical form and a melody, as in Bach's famed improvisation of a 6-part fugue for Frederick the Great. In flamenco, compás and tradition together provide guidelines within which pure improvisation is possible, but the degree of improvisation depends very much on the experience and limitations of the performers, as well as on the palo being performed. At one extreme, we have Sevillanas, for example, which is not improvised; the dancers have memorized a choreography with only minor variation so that complete strangers can dance it as couples, and the singer and guitarist know exactly how many cycles of compas will comprise each copla and when the "Sevilanas" step will be danced during each copla. Bulerias, at the other extreme, is usually improvised with complete reliance on the flow of visual and musical cues between performers. In the beginning, many students learn set pieces that include no improvisation whatsoever, even when learning palos that should be improvised. With experience, greater degrees of improvisation become possible by learning to read the flow of cues between performers that allows them to anticipate the direction the performance will take. These include such devices as dancing a llamada or listening/watching for a llamada as a warning that a change is coming, listening for resolution in traditional chord or melodic progressions, or listening

for the key change (often from minor or Phrygian mode to major) that commonly come before the conclusion. The "lead" can also be handed from one performer to the next so that everyone knows from whom to take their cues. In order to achieve the greatest synchrony between performers, some degree of rehearsal is usually necessary, even for the most experienced. It is not unknown for experienced performers to count the number of compas cycles between stops in musical/dance phrases to allow them to plan ahead. Of course, it is also essential to know the traditional overall structure of the piece being performed. Ultimately, the goal of the performers is to maximize the degree of improvisation in order to achieve the spontaneity that so characterizes flamenco.

Indice: Index finger. Right hand guitar notation symbol - indicated by a lower case 'i'.

Intermedio: middle

Ir con tiento: to move slowly.

Jaberas: (song form) An offshoot of Fandango Grande, it is closely related to the Malagueñas and is from Malaga. The Jaberas is supposed to be Toque Libre, without compás and un-danceable. However, Carmen Amaya claimed that her grandfather introduced the Jabera as a dance form. She called it a kind of Soleá.

Jalear: to shout jaleos as encouragement.

Jaleos: (pron. HELL-AYE-OS). (1) Primitive cante, baile and toque chico, said by some to be the oldest form of flamenco from Cadiz. (2) Shouts of encouragement or appreciation in recognition of the duende. A person doing this is called a jaledor (male) or jaleadora (female). These players also provide rhythmic effects such as palmas (hand clapping) and pitos (finger snaps) and act as a sort of cheer squad for the up front performers.

Jarana: "spree" when a group enjoys themselves doing flamenco.

Juerga: A festive binge of drinking, music, and merrymaking. Jam session.

Letras: ("letters"). These are the lyrics of a flamenco song, a section of a dance equivalent to a verse of a song. Used in the singular, it applies to a single verse. Letras are commonly applied to gypsy cante, whereas *copla* is applied to Andalucian folk music such as sevillanas and fandangos.

Levante: This is a geographical area stretching from Almeria in eastern Andalucia up to Valencia. This area gives its name to the so called Cantes de Levante (songs of the Levante). These are the minera, taranta, murciana, and cartagenara.

Livianas: (Song, toque, and dance grande) This song evolved from being a Toná Liviana, a song without accompaniment or compás, to a style with guitar accompaniment performed to the compás of Siguiriyas.

Llamada: Call. This is a series of dance steps, a chord progression or a melodic line which alerts the other performers that a section (or an entire number) is ending. Llamada can be used to cue the singer to begin the next verse.

Malagueñas: (Regional style) (cante and toque intermedio libre.) These evolved from the Verdiales in the Fandango family and can have a similar rhythm and form. According to Juan Serrano, the well known semi-classical Malagueña by the Cuban composer Ernesto Lecuona is based on the regional style of Malagueña. Donn Pohren however, believes it was influenced by the Flamenco style. These are often performed with castanets.

Mantilla: lace veil worn on the head, often with a pieneta.

Mantón: Embroidered silk shawl with long fringes. Used by dancers to enhance the visual impact of their performance.

Marianas: a nearly-extinct form of cante and toque libre chico, sometimes called Tientos de las Marianas. It faded to obscurity in the 1930's after being popularized by Pastora Pavan. The name

Mariana is variously said to refer to the author's sweetheart, or to a performing monkey owned by a gypsy street performer.

Martillo: Hammer. It can also refer to a quick did of the heel by a dancer.

Martinetes: (cante grande a palo seco and originally without compas) Songs of the blacksmiths, originally of Triana, often accompanied by the sound of the blacksmiths hammer (martillo) striking the anvil. Since 1952, when it was danced by Antonio in the film "Flamenco" (in Spain called, "Duende y Misterio del Flamenco"), it has adopted the compas of siguiryias (Sevilla, 1999). See also TONAS.

Media planta: half-sole striking the ball of the foot on the floor. Sometimes used synonymously with golpe.

Melisma: (plural melismata) Series of notes sung on a single syllable. To the ear unaccustomed to it, the sound may seem like unmusical wailing. It is the singing of a single syllable of text while moving between several different notes in succession.

Mesón: bar restaurant where people can gather and perform flamenco informally, usually cante and baile chico.

Milonga: (cante chico) This song form originated in the Rio de la Plata area of Argentina. Sometimes played in 4/4 time in A minor; it

is similar in some ways to the Farruca, except that the falsetas are more lyrical. It has syncopations and a mood of controlled passion reminiscent of the Tientos. The compás can also be variable: sometimes free, sometimes well defined. The song modulates from minor to major at certain times and in places displays distinct rhythmic and melodic reflections of the Argentinean Tango.

Mineras: (cante libre) The word comes from Minero (miner) and, unsurprisingly, deals with mining themes. It is one of the group of songs known as cantes de Levante. It is basically a variation of tarantas with a mining theme. See *Tarantas* and *Tarantos*.

Mirabrás: (cante, baile, toque chico) One of the group of songs known as Cantiñas. This is in many ways identical to Alegrías, but lacking the dynamic quality and grace.

Misa Flamenca: Catholic mass set to flamenco music.

Mozárabe: Christians living among moors, also the language of same

Muñeca: wrist. Munequeos also refers to hand and wrist movements typical of the art of flamenco.

Murcianas: (Song and dance form) One of the group of songs known as cantes de Levante, now extinct. Possibly an ancestor to the cartageneras.

Nanas: cante chico, Cradle songs, traditionally not played although Bernardo de los Lobitos' Nana in the Hispavox Anthology is an exception.

Nuevo Flamenco: name given during the 1980s to a younger generation of flamenco artists who were influenced by other contemporary and traditional forms of music, jazz in particular, but also rock and pop, as well as the South American mix of salsa and rumba. See Flamenco puro.

Nudillos: knuckles. It is a common practice in juerga and café settings for listeners to keep compás by rapping their knuckles on table tops.

Olé: An exclamation of approval or encouragement.

Palillos: "Little sticks." Castanets, not used in flamenco puro.

Palmares: An extinct cante similar to the Temporeras.

Palmas redoublás or palmas encontrás: palmas in contratiempo.

Universal Flamenco

Palmeros: Musicians that clap to accompany performers, it requires a highly skilled performer to do well.

Pañuelo: scarf or handkerchief.

Pasada: a pass, as in passing a partner during the course of a dance. *De Pecho* means to pass chest-to-chest. *De Espalda* means to pass back-to-back. Also an introductory dance passage in Alegrias. In Sevillanas, a passing step in which partners change places.

Paseillo: same as paso. The dancer may appear to walk casually.

Paseo: Walk. It's a walking step that connects two sections in a dance. The dancer may walk while striking poses without losing the compás in the steps. It is also the opening ceremony at a bullfight.

Paso: a step.

Pasodoble: A form derived from bullfight music; of questionable validity as a flamenco style.

Patada: see desplante.

Payo: Non-Gypsy. It's believed to be prison slang for "sucker" or "easy mark".

Peineta: large ornamental comb worn in the hair.

Peña: club frequented by aficionados of cante.

Perricón: an extra large fan (abanico) used in dance.

Peteneras: (cante, toque, and baile intermedio or jondo) The general mood of this form is one of sadness. The slow measured rhythm is notated in alternating bars of 6/8 and 3/4 like Guajiras. Also like the Guajiras, its 12 beat compás is identical to the Bulerias, but very much slower. The name may be derived from the village of Parerna de Rivera, near Jerez de la Frontera. A superstitious legend connected with its origin endows Peteneras with a certain mystique. According to this legend the main character is a beautiful young prostitute called Dolores (in some versions, Petenera is her name, another possible origin of the palo name). She died a violent death at the hands of one of her lovers. For some authors, the word prostitute is a little severe and they prefer a more poetic description such as, "a beautiful young temptress who stole men's hearts". After her death, songs were created around the story. The superstition surrounding Peteneras was enhanced by misfortunes that followed later public performances. One account is of a dancer who played the part of Petenera and died a choreographed death on stage, following the story line from the legend. The four male dancers involved in the show carried her off stage on their shoulders singing, "La Petenera has died and they are taking her to be buried...." Backstage, it is said, they discovered that the dancer

really was dead, reputedly from a heart attack. This story almost certainly derives from the death of a singer/dancer named Mari Paz, who in 1945, had a premonition of her own death after performing a *Petenera* and died shortly thereafter of a chest infection. Her funeral was tumultuous and the subsequent tabloid press ultimately led to the superstition that it is bad luck to perform the Peteneras. However, every year in July, the people in the village of Parerna pay homage to this form of cante and to Dolores by hosting a national Peteneras song competition. It is fairly certain that Peteneras was originally a song of the Sephardic Jews before they were expelled by the Inquisition. The evidence comes from a verse which makes reference to a beautiful Jewess on her way to a synagogue. This would date the song back as far as 1492, which is when the Jews (and the synagogues) were expelled from Spain by Ferdinand and Isabella. These Sephardic Jewish refugees fled to the Balkans, Turkey, and other Middle Eastern areas where many still speak an ancient form of Spanish and sing some flamenco cante (including Peteneras) that may date from the time of the Inquisition.

Phrygian: The 3rd Greek mode named after Phrygia, a kingdom in the west central part of the Anatolian Highland, part of modern Turkey. The Phrygian mode was once thought to possess the power to intoxicate those who heard it. According to legend it was once

made illegal for this reason. Interestingly, it is the fundamental tonality of most flamenco music. The Phrygian mode in flamenco adds a raised 3rd degree of the scale in addition to its regular minor 3rd scale degree.

Picado: A guitar playing technique. Playing scale passages by alternating the index and middle fingers. Normally executed apoyando (with rest strokes). A few guitarists have developed picado in which the annular finger is used.

Picar: to play picado.

Pie: foot.

Pisar: to fret the strings of a guitar.

Pitos: Finger snaps

Planta: Sole of the foot. Dance: Sometimes refers to a strike of the ball of the foot on the floor, sometimes the flat.

Playeras: (cante, toque, baile jondo) The most plaintive, pessimistic, and forlorn form of siguiryias, probably originally a song of lament, mourning and burial.

Polo: (song and dance form, cante jondo) An ancient form, exactly the same as Caña (q.v.) and Soleá, except for it's distinct melodic line. The ay ay ayes are also a different length. The Polo y

Caña can sound like a mixture of Soleá and Alegrias in E, having the compas of both.

Punta: Toe of the shoe.

Pregón: Cante based on street vendor's calls. Caramel and peanuts seem to be favoured themes. Probably Latin American or Caribbean in origin (lit. trans: "announcement").

Punteado: Plucking technique (guitar).

Quejío: Lament; also passages of "ay". Can be used as a "temple", salida, a remate, or as part of a song.

Ranchera: a Mexican contribution to the cancion de ida y vuelta (q.v.) aspect of flamenco.

Rasgueo: Also rasguedo, or rasgueado. From *Rascar*, meaning to scratch. Right hand strumming technique in which the backs of the fingernails are dragged across the strings, often with interspersed upward strokes of thumb and/or index finger (pron. RAH-AY-OH).

Recoge: from recogir (to gather). A common arm gesture used by the dancer to warn other performers that a llamada will begin in the next compas. It resembles a gesture of gathering by pulling the arms in toward the chest, sometimes while bending forward at the

waist and taking several steps backward. Other shoulder gestures can also be used as a recoge.

Redoble: A series of four or five beats compressed into one or (morst commonly) two beats of compás. Redobles can be used anywhere in the dance to provide dynamic accents. They are commonly used in a LLAMADA or in the end of a section.

Redonda: flamenco voice. See *voz naturale*.

Remate: Finish or resolution. The close of a falseta or a phrase in cante or dance.

Respiro: a break in the cante for the singer to take a breath.

Roma: Gypsy language; It's also a word for the Gypsy race(s).

Romance: a story sung in flamenco rhythm, a Ballad.

Romanes: The Gypsy word for the original (non-Spanish) Gypsy language. (ROM-NESH)

Romeras: (Song and dance form) One of the group of songs known as Cantiñas. Almost identical to Alegríasbut commonly in the key of C major. Like the Mirabrás, Romeras was probably artificially conceived and created to add variety to the repertoire of songs sung in the Café Cantante of the late 19th century.

Rondeña: (1) (Song and dance form) These are songs from the mountainous area of Ronda, in Málaga. If Verdiales are the fandangos of Málaga, then Rondenas are the same of Ronda. There are those who believe the name comes from the word 'Rondar', which means 'to patrol' or 'to prowl around'. In this context, Rondeñas were probably originally the songs of young men serenading their loved ones from beneath their windows. For the guitarist, the rhythm and chord sequence of Rondenas are identical to Verdiales. This traditional song form has no connection with the guitar solo Rondeña of Ramon Montoya.

(2) (Toque libre) A musical form created specifically for the guitar by Ramon Montoya. He is said to have developed it from yet another form called Rondeñas which is different to the one described in the previous definition. Uses an alternative tuning for both 3rd and 6th strings (DADF#BE) Similar tuning to the Elizabethan Lute, which is the same up an interval of a minor third. In recent times, Ramon Montoya's Rondeña has developed from a purely musical form to one which is also sung and danced.

(3) (Song and dance form) This third form is believed to have been the toque of the bandits who practiced their trade in the mountains near Ronda. This obscure musical form is rhythmically reminiscent of the Taranto.

Saetas: (Cante grande, neither danced nor played) Religious chant in worship of Jesus and Mary during Holy Week religious processions. They are generally agreed to be of Jewish origin. The original form, still sung in the mountains around Granada, is centuries old. Incorporated into the flamenco repertoire in the 20th century, modern Saetas can be similar to the Martinete or can adopt the compass of Siguiryias. The elaborate Saetas of Holy Week in Seville have become famous, but Pohren suggests that the original intent has been distorted by an excess of publicity.

Salida: literally "exit" but in flamenco means to exit from backstage and enter the stage, so it actually means entrance, beginning, usually of singer or dancer's performance.

Seguidilla: A Spanish folk dance that has no connection with Siguiriyas, although the names are sometimes used interchangeably.

Serranas: (Song and dance form) Serranas was probably originally a 19th century folk song. It made it's way into the flamenco repertoire courtesy of the famous singer Silverio. It is a style of song-story with the same compás as Siguiriyas but played in E instead of A so has a different mood and texture, though some of the same falsetas can be transposed. It is related to Livianas and Caña. Its verses tell of life in the mountains among the bandits and smugglers. It is danced in a similar style to the Siguiriyas.

Sevilla: Seville. Regional capital of Andalucia.

Silencio: Literally, silence. (1) May refer to any section in a performance when the guitar remains silent, such as when a dancer builds up speed in his or her footsteps. (2) Silencio also traditionally refers to a section in Alegrías in which the singer remains silent, which is played in a minor key at a much slower pace, normally lasting for exactly four or six cycles of compás (silencio sensilla) but may be extended by an extra 4 cycles (doble). It may be characterized by slow and dramatic sweeps of the thumb across the strings to imitate the sound of campanas (bells). The silencio in Alegrías therefore could in some instances be correctly called campanas (bells) for this reason. During the silencio, the dancer emphasizes poses and braceo rather than footwork.

Soledad: Loneliness, solitude; the emotion expressed by Solea.

Solo de pie: dancer's solo without guitar or cante, often with palmas.

Sordas: Soft, or muffled hand claps. See *palmas*.

Tablas: literally, "boards"; the stage on which the dance is performed; *tiene tablas* means "to be an experienced performer".

Tacón: Heel. Also a dance term indicating a drop of the heel from a planta or golpé position. Also *talón*.

Taconeo: Heelwork, sometimes footwork.

Tarantas: (Cante jondo, and toque libre) Taranta is the song form of the miners, sung without compas. Originating in the province of Almeria, these songs are also associated with the neighbouring provinces of Jaen and Murcia. Tarantas reflects a sense of tragedy, deprivation and sorrow. The dark sounding discordant melodies and open chords used in Tarantas give it a distinctive Oriental (Arabic) character. Usually played in F# phrygian. The verses of Tarantas and Tarantos can be sung interchangeably.

Tarantos: (Song and dance form) A danceable form of Tarantas with a steady compás in 2/4 time. One of the Cantes Mineras, or mining songs, "Tarantos" was a local name in Linares given to miners from Almeria. It is an evolved version of the taranta minera, and has taken several forms. Many of the best known singers of Tarantos came from Almeria (including Juan Abad Diaz "Chilares", Pedro el Morato, Frasquito Segura "El Ciego de la playa", Juan Martin "El Cabogatero", and it is through their influence that the Taranto de Almeria evolved. Other various styles include Taranta Minera, Levantica, Basilio, Cartagena, and Tarantos Linarenses. These variants evolved when cafes cantantes became established in

the area between La Union and Cartagena around 1895, causing professional singers to adopt the form. The first recorded version was by La Niña de los Pienes in 1910. The strong influence of Manuel Torre in 1929 transformed the Tarantos into its finished modern form, although the later influence of Antonio Piñana and Pencho Cros also played important roles in establishing the Tarantos as it is known today. Rosario (of Antonio and Rosario) credits herself as being the first to choreograph Tarantos in 1951 (Sevilla, 1999, p. 197), although Carmen Amaya performed it in the 1940's. The term "mineras" is also taken to include the various styles of Tarantos.

Tiranas: An extinct palo, very similar to Malagueñas.

Tocaor: tacaor Male flamenco guitar player

Tocaora: Female flamenco guitar player

Tocar: To touch. With music it means to play.

Tonás: (Cante Jondo) It comes from the word Tonada, meaning tune or popular song. They are widely believed to be the earliest flamenco song forms. Included in this group are the MARTINETES (songs of the blacksmiths), CARCELERAS (songs of the prisoners), DEBLA (of obscure origin) and perhaps even an early form of Siguiriyas. Tonás are song-stories that were neither played of

danced. They were sung 'a palo seco', which means unaccompanied except perhaps with the rhythmic beating of a palo (stick) on the ground. In the case of the Martinetes, the song would be accompanied by the sound of a blacksmith's hammer striking an anvil.

Tono: Tone or key. "Buscar el tono" is to look for a singer's key.

Toque: 1. Guitar playing. 2. Flamenco interpretation on the guitar. 3. A flamenco form (palo) or specific piece, such as Alegrías.

Toque libre: This is a guitar term which means to play freely, without compás or time signature. Most toque libre are derived from the Fandango grande and include Malagueña, Granadinas, Tarantas, and Rondeña. There may be passages within any toque libre, which follow some sort of compás for a while, at the discretion of the guitarist, before returning to a freer mood. This style of playing lends itself well to improvised experiments in melody and rhythm as a piece progresses. A short introduction of toque libre is sometimes used to introduce a song with otherwise well-defined compas.

Torsión: stages, usually in the *solea*, wherein the dancer reaches a more or less ecstatic state.

Traje Flamenco: flamenco costume, often refers to full length dress.

Universal Flamenco

Triana: The gypsy quarter of Seville, regarded by some as the birthplace of Flamenco, although it is unlikely that an art form with such diverse cultural roots would have a single locale as its birthplace.

Trilleras: traditional country song, sung by wheat grinders, usually flattering their horses or village women while their horses or mules pull the wheat grinder over the wheat. Compas is determined by hoofbeats.

Villancicos: A genre of Spanish song, dating from the 15th century. It is a poetic and musical form and was sung with or without accompanying instruments. Originally a folk song, frequently with a devotional song or love poem as text, it developed into an art music genre. The Villancico of the 17th century has a sacred text, often for Christmas. In the 18th century this form expanded into a dramatic cantata with arias and choruses. In the 20th century the use of the term is restricted to the Spanish Christmas carol. Although not true flamenco, it would not be unusual to see this song form on a flamenco recording. Villancicos are not characterized by any particular melody or rhythm but rather by fitting popular Villancico-letras (text) to the appropriate flamenco rhythm, be it tangos, tanguillos or bulerias, any palo that can be adapted. See Saura's *El Amor Brujo* for an example.

Verdiales: (Song and dance form) This is a lighthearted style of Fandangos from Málaga which takes its name from a village called Los Verdiales. It is Málaga's equivalent to Fandangos de Huelva, performed at a slower pace with the accent on the first beat of every bar. Verdiales is considered to be folklore and thought to be the oldest existing Fandangos in Andalucia. There are two types of Verdiales. The 'regional' Verdiales is the folkloric style accompanied by tambourines, violins and other instruments as well as the guitar. The 'flamenco' Verdiales is accompanied only by the guitar.

Vito: (Song and dance form) This is an old Andalusia folk song in 3/4 time (or more recently to the compas of bulerias) which recently has found it's way into the flamenco repertoire. The distinctive melody line is preserved by the few artists who have recorded it. Paco de Lucia for one, has recorded a couple of different versions. It also frequently appears in sheet music published in the 1950's. Like the modern recordings, the interpretations are different but the melody line remains unaltered.

Zapato: Shoe

Zorongo: This is an old folk song resurrected by Garcia Lorca. In recent years it has quietly made its way into the flamenco repertoire. It has a 12 beat compás consisting of a theme verse in

the compás of a slow tango, alternating with verses in the compás of a sensual, more lyrical version of Peteneras. Near the end it takes on the compás of Bulerias. This sequence of slow and fast may also be alternated. Paco Peña plays a Zorongo on his album Fabulous Flamenco. Sabicas played one under the title "Guadalquivir".

ABOUT THE AUTHOR

 IRENE RIMER is a Philosopher, Christian Metaphysics Practitioner, Ordained Minister, and Book Author. She is also an experienced Accountant, and Flamenco Artist.

Ms. Rimer has a Doctorate degree in Philosophy, Masters degree in Metaphysical Counseling, and is also an Ordained Minister of the International Metaphysics Ministry. She is available for Metaphysical counseling, lectures, and services.

Dr. Rimer studied Astrology under the mentorship of Stephanie Jean Clement, former president of the American Federation of Astrologers, and also, the Rosicrucian Fellowship. She offers Astrology classes, lectures and personal consulting, as well as natal and progressed astrology charts and interpretations.

Ms. Rimer has a B.S. degree in Business Administration and Accounting from Barry University, and completed post-graduate

Universal Flamenco

studies in Business at Samford University; she has worked as an Accountant for 30+ years.

Dr. Rimer's latest books are available at amazon.com.

As an artist, Irene was trained in Ballet by Madam Nina Novak, and was privileged to study Flamenco & Classic Spanish at the prestigious original Amor de Dios studio in Madrid. Once "baptized" by Maria Magdalena with the artistic name "La Chata," Irene performed in the Ferias in Andalusia, and in tablaos in Spain and abroad. Ms. Rimer has shared the stage with Estrella Morena, Pepe de Malaga, Jose Luis Zorrilla, Emilio Prados, Manolo Vargas, Paco & Celia Fonta, La Morita, La China, La Tati, Antonio Serrano, El Nano de Jerez, Gabriela Ortega, Juan el Extremeno, Leo Heredia, Miguel Hernandez, Pedro Genil, Pepe Torremolinos, & Juan de Alba to name a few. She was El Chino de Malaga prima flamenco dancer and the dance partner of Jose Serrano and Paco del Puerto.

Ms. Rimer was the Director at Irene Rimer Dance Academy where she taught Ballet, Flamenco, and Oriental fusion for ten years. The studio was recognized as one of the best dance studios in the Miami area, with a faculty of up to seventeen instructors. Irene taught for nine years in Birmingham, Alabama, and was in the advisory board,

and a member, of the Alabama Dance Council. She has also choreographed for opera companies.

Irene teaches percussion & advocates the acquisition of rhythmic precision, which she calls "emotional mathematics," allowing the disciple to evolve and benefit all areas of life.

FOR MORE INFORMATION ABOUT THIS WRITER, OR FOR LECTURES, MASTER CLASSES AND PERFORMANCES, Please visit our web page and contact us.

www.irenerimer.com

www.ingramcontent.com/pod-product-compliance
Lightning Source LLC
Chambersburg PA
CBHW051217170526
45166CB00005B/1941